My First Trip to PARIS

A FAMILY'S TRAVEL SURVIVAL GUIDE

Text by Sara DeGonia
Photographs by Giovanni Simeone

SIME BOOKS

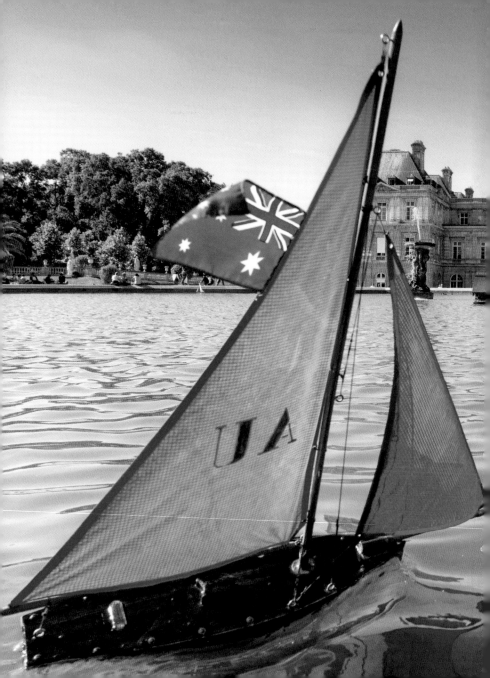

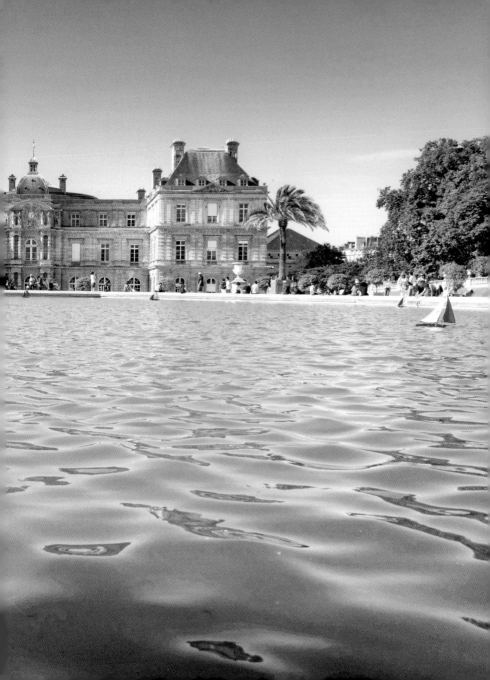

You've saved your pennies, perused your page-a-day French calendar for a full year, and decided as a household to fly to Paris for a much-needed holiday. If your family is ready for a challenge and adventure, then you will surely reap the innumerable rewards of a memorable first trip to Paris, France.

My *First Trip to Paris* is meant to offer guidance to navigate your family toward a successful and enjoyable vacation. Packed with tips and tricks from prices to potty breaks, this guide can provide a hint of flavor to inform you in your planning and journey.

(Speaking of les toilettes, many public restrooms require a small fee, so have some small change euros on hand at all times.)

Within these pages you'll find recommended highlights and potential can't-miss opportunities with a nod specifically to visiting each spot with children in tow. Taking into account activities and tidbits that might interest your kids, this guide seeks to prepare you for the endless possibilities that Paris has to offer! In turn, each entry lists a corresponding website where you can find logistical information like directions, hours, and fees if needed.

Keep in mind a potential language barrier, and don't let it stop you from enjoying every activity you encounter. Practice polite tourist etiquette, and you'll find that most locals are happy to help you navigate your way around the city.

In some ways, My *First Trip to Paris* is simply the story of a typical family—like so many others—exploring a city and taking a dream vacation.

Be sure to bring along your metro map, French phrases, walking shoes, and sense of adventure; and your entire family will be ready to go. Bon voyage!

PARIS

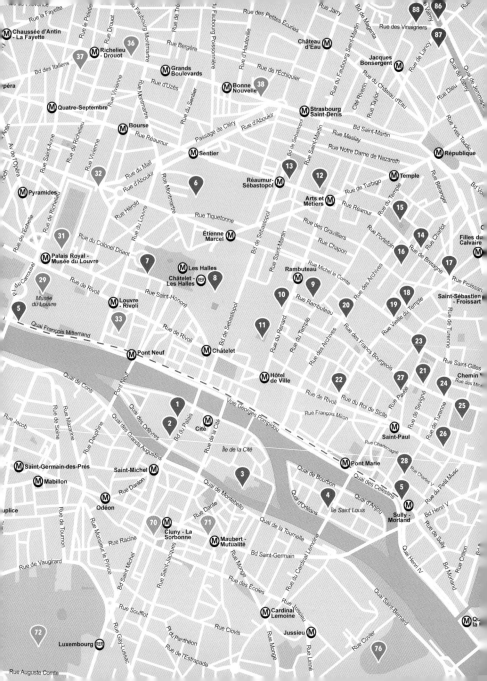

CONCIERGERIE
PALAIS DE LA CITÉ
ROYAL PALACE

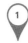

1st arrondissement
2 boulevard du Palais

www.paris-conciergerie.fr

Ⓜ❹ Cité
Ⓜ❶ ❼⓫⓮ Châtelet
ⓇⒷⒸ St-Michel - Notre-Dame

If naughty behavior is creeping into your travels, consider giving the children an innocent scare with a visit to the Conciergerie, which served as a prison during the French Revolution. The monument is not spooky at all—rather a beautiful part of the former royal palace (Palais de la Cité) on the Île de la Cité—but mentioning an extended stay might be in the cards for any kids who don't straighten up could very well help manners and conduct improve.

Of course, if scare-tactic parenting isn't your style, you can stick to the other fantastic features of this locale. Situated on the banks of the River Seine, the site served as one wing of the first royal palace in Paris, before being used to detain enemies of the Republic at the end of the eighteenth century. One such prisoner was Queen Marie Antoinette, who was held at the Conciergerie leading up to the day of her execution. Get a peek at her cell conditions, and discover what the circumstances were like for the captives awaiting trials—or unfortunate trips to the guillotine.

Children receive free admission to this site, and if you have the Paris Museum Pass, the Conciergerie is among the included sites you can visit at no extra charge. If you're in the area, this attraction won't take more than ninety minutes, so it's an excellent option for an unexpected hole in your itinerary.

Signs for the exhibits are written in English, French, and Spanish. Make the visitors standing in long lines jealous by printing your tickets out online ahead of time to jump the queue, and consider combining with a trip to Sainte-Chapelle (page 14).

Beward that not all areas of the building are particularly stroller-friendly, but the air conditioning is a welcome presence on a hot summer day.

SAINTE-CHAPELLE
PALAIS DE LA CITÉ
ROYAL PALACE

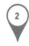

2

1st arrondissement
8 boulevard du Palais

www.sainte-chapelle.fr

Ⓜ❹ Cité
Ⓜ❶❼⓫⓮ Châtelet
ⓇⒺⓇⒷⒸ St-Michel - Notre-Dame

This exquisite Gothic chapel on the Île de la Cité features breathtaking stained-glass windows and photo-worthy architecture. A rainbow of colors floods in from sunshine beaming through the windows as you step inside—a sight that may be new and exciting for young children to enjoy. Of course, if your visit occurs on a cloudy day, you might be precluded from this particular effect.

Stories of the Bible adorn the fifteen glass windows throughout the chapel, starting from the Book of Genesis and ending with Revelation. But whether these stories have significance to your family or not, the ornate nature of each pane will capture your attention with its artistic relevance.

Constructed in the thirteenth century, Sainte-Chapelle was originally built to house important relics of Christianity, including Jesus Christ's crown of thorns, which no longer remains within the chapel. The site has undergone multiple restorations, with great measures taken to ensure as much consistency and preservation as possible.

Admission is free for children under eighteen years old (and for others with the Paris Museum Pass), but do note that lines may be long, and you are required to pass through a metal detector to enter. Don't miss the spiral staircase leading to the main chapel after you enter near the gift shop.

If your children aren't quite old enough to be entertained merely by stunning shades of color and impressive arches, then your visit will likely be rather quick. But if the lines aren't too prohibitive as you happen upon Sainte-Chapelle, then a stop inside to witness a moment of historical beauty will be well worth your time.

CATHÉDRALE NOTRE DAME DE PARIS
CATHEDRAL

4th arrondissement
6 Parvis Notre-Dame
Place Jean-Paul II

notredamedeparis.fr

Ⓜ① Hôtel de Ville or Châtelet
Ⓜ④ Cité
Ⓜ⑦⑪⑭ Châtelet
ⓇⒺⒷⒸ Saint-Michel - Notre-Dame

It always helps to have an animated movie on hand when asking your children to relate to a historical location they might not otherwise appreciate. In this case, Disney's *The Hunchback of Notre Dame* has done parents a favor by providing a reason for some young kids to care about visiting this famous cathedral.

Or, if you're the unlucky family who hasn't seen the film, or read Victor Hugo's original romantic-Gothic novel, perhaps you have religious ties to this Catholic church.

But whether or not any of these factors apply to your group, it is still easy to admire the magnificence of this structure as you approach its 200-feet-tall presence, and further still if you step inside and view its wonderfully high ceilings.

A long line for entrance might await you, so if you can convince one family member to hold your spot for a bit, the rest of you can spend some time at the playground in the adjacent park. Or try to plan your visit for first thing in the morning to avoid queueing entirely. Admission is free for anyone under eighteen years old.

You'll want to climb the south tower, about 400 steps, and join the intricate angels and gargoyles in looking out over sweeping views of Paris. Back inside you'll find the imposing church bells, and, after descending from the tower, you can decide whether to join the throngs of others inside the church itself. With sculptures, stained-glass windows, stunning architecture, and an archaeological crypt within this Gothic cathedral on the Île de la Cité, you'll have plenty to choose from, depending on your family's interests. Finally, before heading to your next Parisian destination, take a moment to find a plaque in the area in front of the cathedral that reads "Point Zero," indicating the middle point of France and of ancient Paris. Your child can stand on the plaque and be the center of attention as usual.

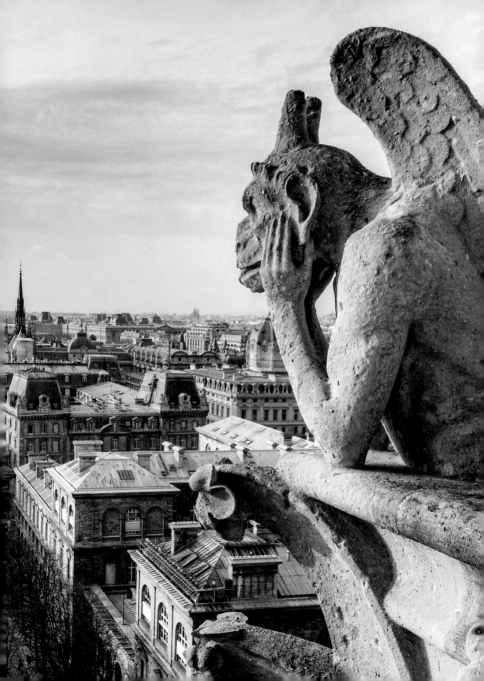

ÎLE SAINT-LOUIS

SAINT-LOUIS ISLAND

4th arrondissement

Ⓜ❼ Pont Marie

Situated within the Seine River, and adjacent to the Île de la Cité, this natural island was originally two islets—one used as a cow pasture—before the halves were joined together to create Île Saint-Louis in 1614. Journey to the island on one of four bridges to admire exquisite homes in a peaceful setting just a short distance from the bustling metropolis that is Paris. Hand the reins to your children, and let inspiration choose your path as you stroll along these serene streets, looking for quaint shops or a quiet café and stumbling upon memorable moments of discovery and contentment. Perhaps youthful instincts will lead your family to Arche de Noé, an upscale toy store complete with wooden music boxes, cuddly plush animals, and elegant tea sets. Nearing holiday time? Pick up a pre-addressed sheet of stationery at the register to send Père Noël (Santa Claus) a note of wishes.

Walk along the tree-lined lanes, admiring the island's ambiance, and stop to watch a street performer entertain. Explore charming boutiques, take in tranquil views of the Seine, and step inside the St Louis en l'Île church to listen in on choir practice—if your timing is right.

Perhaps most important of all, be sure to visit the home of Berthillon ice cream, arguably the best in all of Paris (and beyond), with flavors like white chocolate, salted caramel, lavender, and even foie gras. The family-run business has operated for more than sixty years, and its frozen treats are sold in eateries throughout France.

If you're feeling reluctant to leave the idyllic island, consider extending your stay with some time in one of two parks. Play structures will entertain the kiddos while you imagine picking out the perfect château for your family to inhabit.

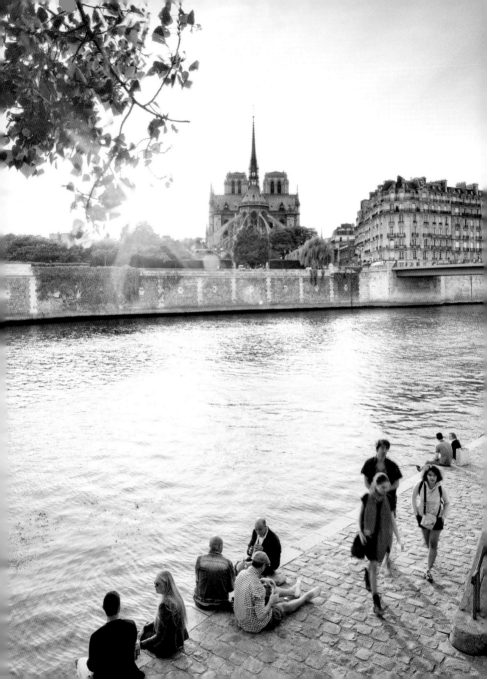

PARIS PLAGES
PARIS BEACHES
(MID-JULY TO MID-AUGUST)

Rive Droite
from Louvre to Pont de Sully

Ⓜ❼ Pont Neuf or Pont Marie
or Sully Morland

Bassin de la Villette
Ⓜ❷❺❼ᵇⁱˢ Jaurès

www.parisinfo.com

Should your visit fall in the summer months, specifically between mid-July and mid-August, make your way to Paris Plages—a series of temporary, artificial beaches for your sandy, sunbathing enjoyment along the banks of the Seine river. Marked by bright blue or white umbrellas, and even the occasional palm tree, this city-planned event brings a seaside sensibility to the steamy season for locals and tourists to appreciate.

Although swimming in the river is not allowed, no doubt much to the chagrin of your amphibious children, a host of other features will prove appealing—especially if you can find room in the mini pool.

Aspects of the setup change slightly every year, but you can expect paddle boating, mini golfing, and various food stalls, depending on the beach you choose. Luck might provide you an open set of deck chairs, an entertaining street performer, or a free musical concert. And recent years have included zip-lining and inflatable roller tubes specifically for children to experience. Most of the beach-centric games and sports take place on the large square facing the Hôtel de Ville, while water-based options are located at the Bassin de la Villette.

Of course, no matter which sunny spot you select for the group, you can challenge the youngsters to a sand castle-building contest (bring your own water) and uncover the architect within.

With easy access to an ice cream cone, plenty of activities to choose from or admire from afar, and a particular patch of beach to call your very own, some time relaxing at Paris Plages can prove just as rewarding on your vacation as any number of sightseeing ventures.

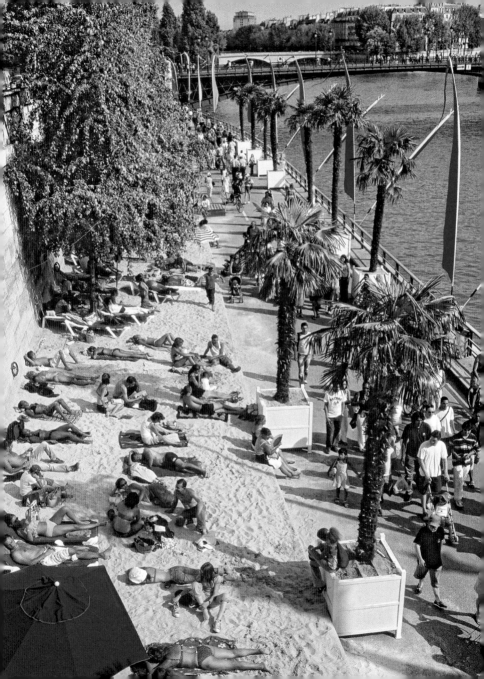

RUE MONTORGUEIL

1st/2nd arrondissements

Ⓜ❹ Les Halles Ⓜ❷ Sentier
ⓇⒺⓇⒶⒷⒹ Châtelet - Les Halles

Not just the name of a stunning Monet painting, the rue Montorgueil is a bustling, pedestrians-only street with enough dining and shopping options to fill any number of hours during your stay in Paris. Beyond Les Halles (page 26) at the southernmost end, this lively avenue contains a variety of options for your perusing and purchasing delights.

Visit, for instance, the famous L'Escargot restaurant—a staple of French cuisine since 1875 (and selling shellfish for decades before that). Or stop in at one of the oldest bakeries in the city: La Maison Stohrer, which has served locals and royalty since 1730, and is known for inventing the rum baba pastry. Don't forget to gaze up and admire the bakery's exquisite ceiling.

If you're looking to feast on oysters while watching passersby from your prime sidewalk seat, you can request a table at Au Rocher de Cancale, a resident of the area since 1804—although originally located in a building across the street.

Perhaps you're looking to assemble a veritable smorgasbord of your own making, in which case the cheese shops, wine stalls, and produce stands will offer the ingredients you need for a bona fide picnic at the location of your choosing.

Let your kids lead the way, and you'll discover delectable riches to share and enjoy, from French onion soup to scores of sweet chocolate.

Beyond delicious dining and indulging in fresh-baked goods, stroll along the rue Montorgueil to find a spot of coffee, a bouquet of fresh flowers, or a glimpse into somewhat-less-touristy life in this picturesque city. Take advantage of this quieter section of the city to experience a taste of Paris when low energy won't allow for a full day of museums and galleries.

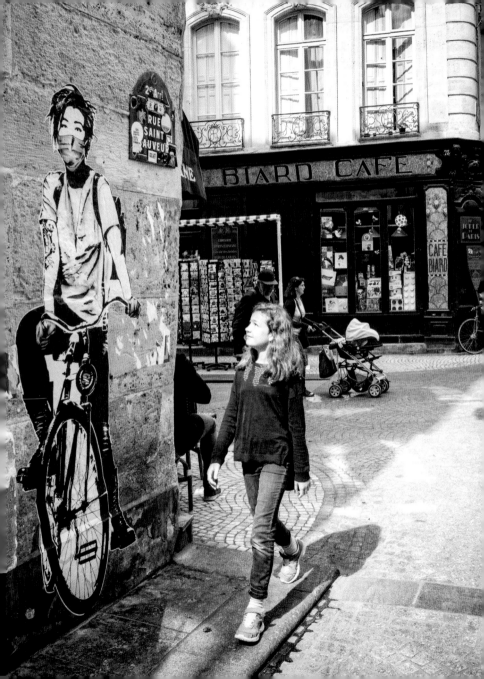

JARDIN NELSON MANDELA : TERRAIN D'AVENTURES
LES HALLES PLAYGROUND

1st arrondissement
1 Allée Blaise Cendrars
Les Halles

Ⓜ❹ Les Halles
ⓇⒺⒺⒶⒷⒹ Châtelet - Les Halles

With its rainbow collection of weird, wacky, and wonderful structures, this vibrant wonderland can't miss in delighting your kiddos as soon as they set their sights on its sprawling collection of outlandish options. Almost like a mini museum in its masterful use of swirling colors and abstract shapes, each piece of equipment has a little something spunky to excite and inspire your children for their best play in Paris. Recently renovated in the last few years, each section of the park produces a new opportunity for fascination and imagination.

You can take a trip on the triptych train for tykes who like transportation, or slither down the bright yellow slide. And adjacent to this paradise is a playground just for youngsters over seven years old—no baby siblings allowed. For these big kids, an exploration up, up into a collection of towering globes will make them feel like kings and queens of the castle.

Fortunately, supervised play is sometimes offered, so you might be able to rely on a professional to keep an eye out, as you check on a youngster or two at each of the separate playgrounds.

A word of advice for families with children on either side of seven years old: make sure both playgrounds are open simultaneously before your visit, or you'll have one or more severely disappointed little sprouts on your hands. Elsewhere throughout the Jardin Nelson Mandela, stroll along among the fountains; or pack a picnic and pick a perfect plot of grass to sit and snack. Look for a public bathroom close by at 44/46 rue Berger.

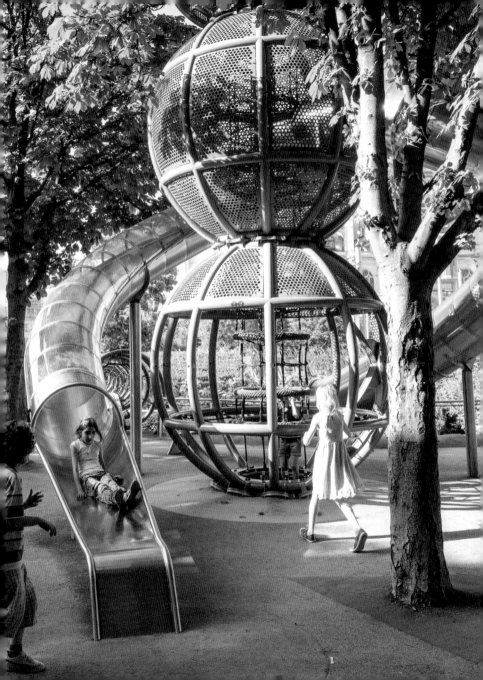

LES HALLES

SHOPPING CENTER

8

1st arrondissement

www.forumdeshalles.com

Ⓜ❹ Les Halles
ⓇⒺⓇⒶⒷⒹ Châtelet - Les Halles

With its rich history as the central food market of Paris for hundreds of years, this expansive shopping center near the Centre Pompidou is more famous among locals for what it once was rather than what it has become since its original structures were demolished in 1971.

But for visitors and newcomers with no nostalgic knowledge of its past self, Les Halles is simply a largely underground hub of metro stops, dozens and dozens of well-known stores, a variety of restaurants, and other entertainment.

You may easily get lost as you stumble from the train platform into the main mall, walking by rows of clothing retailers, cafés, and the movie theater, but if you are looking to pick up a beret, grab a snack, and see the latest French flick, then you'll be in no hurry to find your way out.

Atop the subterranean forum, the Jardin Nelson Mandela and pedestrians-only streets are meant to provide a social area for visitors to gather. It's also a nice spot to enjoy your bite to eat before venturing back to the stores, as many of the forum's shops won't allow you inside with your leftover beverage.

Due to heavy criticism of the design and aesthetic of the renovated buildings, a plan is now underway to add a glass canopy structure that will hopefully improve the overall look of Les Halles, while still letting in sunlight. A new complex is in the works as well, so depending on when you're visiting, you might have access to enjoy the library, dance and music conservatory, or hip hop cultural center.

As you'll want to remember in any highly populated area of the city, keep an eye on your belongings in case of any roaming hands of passersby.

MUSÉE DE LA POUPÉE
DOLL MUSEUM

3rd arrondissement
Impasse Berthaud
quartier Beaubourg

www.museedelapoupeeparis.com

Ⓜ⑪ Rambuteau

Be prepared to make a trip to the gift shop at the end of your visit to the Musée de la Poupée. After exploring an entire museum filled with toys and dolls, it's more than likely that your kids will want to take home a little souvenir of their own.

As you stroll through the permanent collection of more than 800 awe-inspiring antiques, you'll see dolls from a time span of more than 150 years. Journeying from the oldest models to the newest, discover how the toys have changed, how the materials differ, and how clothing styles have evolved.

Many of the dolls appear too beautiful, intricate, or delicate to even play with, but perhaps your children will disagree, so it's fortunate that most are behind glass. As you make your way through each room, ask your kids to pick out their favorite dolls from every time period, and invite them to explain whether their choices are based on hairstyle, facial expression, or general attitude.

If workshops are offered during your visit, you might have the opportunity to dress your own paper dolls, paint a set of Russian nesting dolls, or dream up the perfect dress for Barbie. Or, if time is short as you're trying to get to a slew of Parisian destinations, you can make your visit fairly brief at this smallish museum. As you venture back out in the fresh air, stop by the quaint garden next door dedicated to the memory of Anne Frank.

CENTRE POMPIDOU

10

4th arrondissement
place Georges Pompidou

www.centrepompidou.fr

Ⓜ⓫ Rambuteau
Ⓜ❶⓫ Hôtel de Ville
Ⓜ➍➐⓮ Châtelet
ⓇⒺⓇⒶⒷⒹ Châtelet - Les Halles

From its exterior, the Centre Pompidou looks as if it could be a children's play place or large hamster maze, with its brightly colored external tubing designed for the building's air conditioning (blue), electricity (yellow), and other systems.

Instead, the artistry of the architecture—as well as Alexander Calder's imposing *Horizontal* sculpture out front—hints at a much more sophisticated subject matter within. Inside you'll find the National Museum of Modern Art, housing more than 50,000 modern and contemporary artworks, including pieces by Pablo Picasso, Wassily Kandinsky, and Andy Warhol. With its vast collection, the Centre serves as the largest museum for modern art throughout Europe, however, only about 600 works are available to view at a time. Of course several hundred pieces are still more than you can likely get to during your visit, so you'll have plenty of permanent and temporary exhibits to choose from across two sprawling floors.

Admission is free for anyone under eighteen years old, and workshops are frequently offered for children to experience hands-on learning and enhance their visit. In addition to the art gallery, the Centre Pompidou hosts an expansive public library, movie theater, and bookshop, serving as a cultural center for different art forms. A rooftop terrace provides panoramic views of the city, so make your way to the top before leaving for the day. The external escalators will prove attractive to your daring youngsters—almost like getting a thrill ride with the price of admission. Conveniently located adjacent to the metro, with a roomy courtyard and plenty of dining options nearby, the Centre Pompidou offers an all-encompassing option to spend an easy afternoon.

FONTAINE STRAVINSKY & PLACE GEORGES POMPIDOU

11

4th arrondissement

www.centrepompidou.fr

Ⓜ❶ Rambuteau
Ⓜ ❶ Hôtel de Ville
Ⓜ❹❼⓮ Châtelet
ⓇⒺⒸ Ⓐ Ⓑ Ⓓ Châtelet - Les Halles

Just outside the Centre Pompidou, you'll find a lively square filled with all manner of rotating entertainment. Of course, some varietals are more likely than others: perhaps a proper French mime will be trapped inside a box of his own design.

If the weather is nice, you may stumble upon a bubble maker creating soapy orbs large enough to fit a toddler. Or the whole family can grab a spot on the sprawling, pedestrians-only pavement to watch dancers, dreamers, and magicians showcasing their particular talents.

An artist may draw inspiration from your beautiful group, or a musician might serenade you with her voice or giant, wooden didgeridoo.

Of course, depending on interest, your kids may prefer the skateboarders practicing tricks over the painstaking recreation of a famous painting in sidewalk chalk. If you experience a lull in the street performances, simply grab a croissant and coffee from a café nearby and settle in the square to people-watch while you snack.

Also adjacent to the Centre, you'll want to stop by the Fontaine Stravinsky (Stravinsky Fountain) to admire each of the sixteen sculptures standing within the water. Every sculpture represents a work by musical composer Igor Stravinsky, and most of the interpretations are easy to understand. Challenge your family members to pick out *La Sirène* (The Mermaid), *La Grenouille* (The Frog), and *L'Éléphant* (The Elephant) among the bunch. Take a lap around the entire perimeter—remaining on dry land, of course—to enjoy the complete collection from every angle.

If time is too short to explore the whole of the adjacent Centre Pompidou, consider paying three euros to take the external escalator for a ride toward the sky.

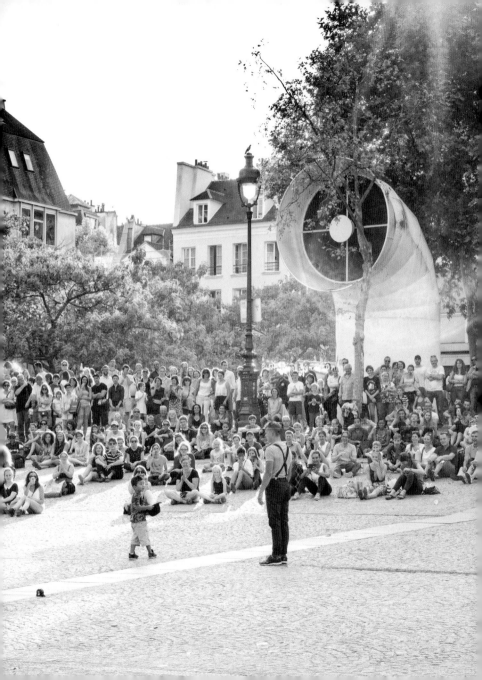

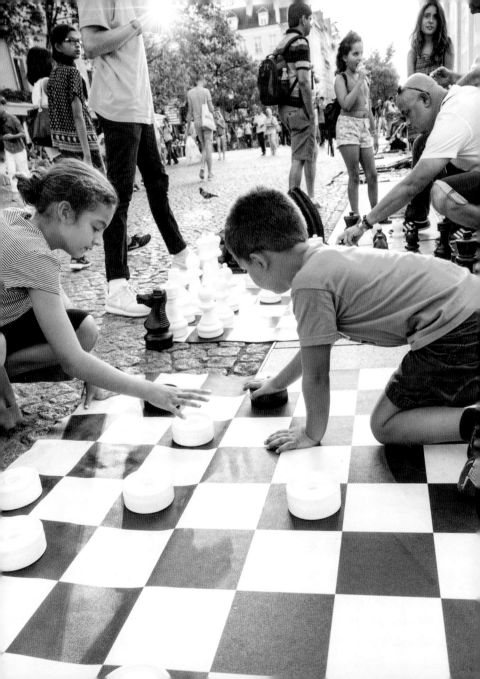

MUSÉE DES ARTS ET MÉTIERS

MUSEUM OF TECHNOLOGICAL INNOVATION

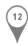

3rd arrondissement
60 rue Réaumur

arts-et-metiers.net

Ⓜ❸❹ Réaumur - Sébastopol
Ⓜ❶❸⓫ Arts et Métiers

Productivity and progress are the name of the game at the Musée des Arts et Métiers, which exhibits more than two thousand inventions (and houses more than eighty thousand objects) from French minds, and others around the world.

If you take the metro to arrive—and in this instance you certainly should—you'll exit the train onto a platform with impressive, shining copper walls. Giant gears hang above your head, getting your brain turning toward the brilliant visit ahead. Peek into port holes on the wall to catch a glimpse of machines akin to those you'll find once inside the museum.

Fascinating origins are represented with items from seven different categories, including Scientific Instruments, Communication, and Transport.

Some of your group might find the seemingly fragile bicycles, vehicles, and planes most intriguing, as you happen upon a gasoline tricycle from 1887, or a Model T automobile from the Ford Motor Company in 1913. The kids can imagine piloting Clément Ader's Plane #3, or another turn-of-the-century flying machine, as they climb up to get a bird's eye view of the classic inventions hanging from the ceiling and below.

For little (or big) scientists, be sure not to miss one of the most well-known objects in the collection: the impressive Foucault pendulum sphere. Check for demonstration times to see the pendulum in action. Elsewhere in the museum, look for the lunar robot designed to explore Mars, and marvel at the sheer size of the massive IBM computer.

Astound your children as you happen upon modes of communication from many decades before, including a camera from the late nineteenth century, a telegraph, and an early telephone system. Perhaps, by comparison, you can encourage a little appreciation for the present-day convenience of all-in-one smartphones and other devices.

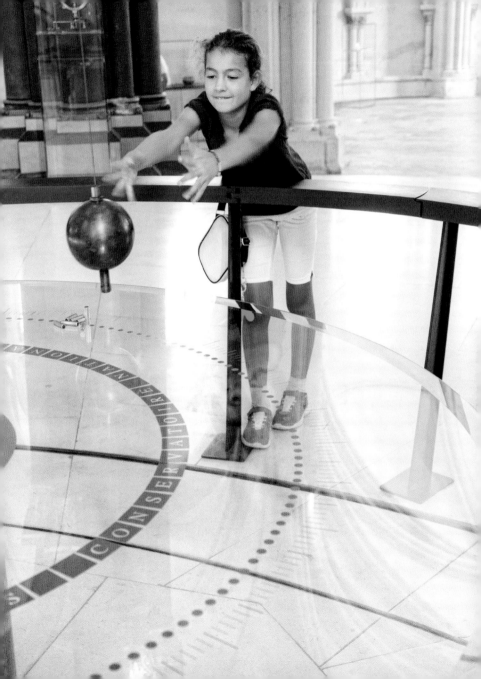

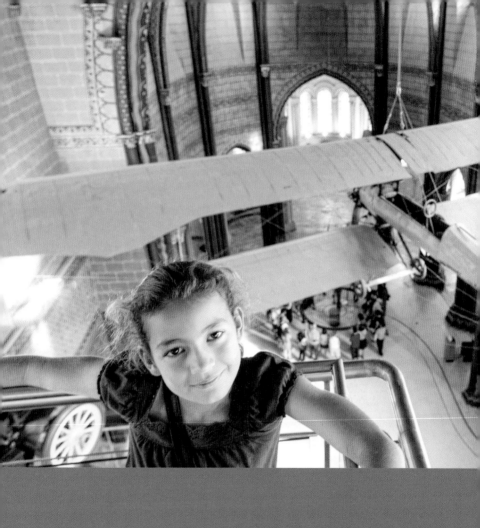

Speaking of smartphones, consider downloading the free mobile app to further enhance your visit. The app includes audio guides, complimentary info about what you're seeing, and virtual views around the museum. As you continue exploring, the sheer extent of uses and purposes for the objects you'll discover is sure to impress, ranging from items still used today (albeit in newer forms), like sewing machines and microscopes, to machines you might never have otherwise known existed. Perhaps you can even get the kids thinking about what sort of creative configuration they'd like to invent, and where it would live in the museum.

Don't leave without locating one (or both) of two Statue of Liberty representations, whether it be the nine-feet-tall original plaster model that Frédéric-Auguste Bartholdi used to plan and design the larger-than-life version we know and love in New York City, or the bronze figure situated in the courtyard outside. Plan on spending about two hours or so exploring the museum within an ancient abbey from top to bottom. Consider checking the website ahead of time to join a family workshop (Saturdays, for seven- to twelve-year-olds) or family visit (Sundays at 11 a.m.).

If hunger prevails during your time at Musée des Arts et Métiers, a restaurant on the ground floor can take care of empty tummies.

GAÎTÉ LYRIQUE
CULTURAL CENTER

(13)

3rd arrondissement
3bis rue Papin

gaite-lyrique.net

Ⓜ❸❹ Réaumur - Sébastopol
Ⓜ❸⓫ Arts et Métiers
Ⓜ❹❽❾ Strasbourg - Saint-Denis

Just a ten-minute walk from the Centre Pompidou, this cultural center hosts a wide range of artistic opportunities for the whole family to enjoy.

With a rotating lineup of events and performances, you can find an exhibition exploring the dimensions of music, or a one-night blues concert. There are lectures to attend, with musicians or artists, and festivals celebrating films and pop culture.

Workshops are geared toward any range of age group—a past session taught grandparents how to play video games to relate to their grandkids with Mario and *Minecraft*.

If the temporary offerings aren't to your group's likings, there's always the local food market to explore on Tuesday evenings, or the chance to see a film screening. You can check out the café or grab a drink at the upstairs bar, peruse the library and media area, or see if the video game consoles are unoccupied on the first floor near the boutique.

Most likely the Gaîté Lyrique is one spot you'll want to research a little before visiting—take a glance at the online schedule of events to see if any offerings during your time in Paris are worth the trip. Perhaps you'll find an audiovisual children's concert geared toward your littlest ones, or a spooky glow-in-the dark musical like *The Wolf Under the Moon*. Whether you find something appropriate for your family unit depends largely on the calendar lineup during your stay. You'll want to inquire about possible language barriers while researching as well; luckily video games are fairly universal.

And just in case you were wondering, back in the 1970s this building housed a circus, including an attic full of elephants. But they've probably cleaned up after the gentle giants by now.

PNY

3rd arrondissement
1 rue Perrée

Ⓜ❸ Temple
Ⓜ❽ Filles du Calvaire

If your child's palate hasn't quite warmed up to French cuisine, Paris New York, or PNY, serves up the simplest menu of burgers and fries—but with a modern twist. Not only are the taste combinations somewhat unique, but PNY also chooses the highest quality components and crafts your food with painstaking care.

Their secret ingredient is matured beef, which possesses a particular flavor profile for the juicy hamburger options on the PNY menu. Choose from three or four different combos, including topping selections like aged cheddar, onion confit, and bacon. Or if red meat isn't your first choice, you can opt for the crispy chicken fillet or the vegetarian portobello mushroom burger.

Home fries and loaded fries (another opportunity to enjoy melty cheese and salty bacon) round out the menu, but what more do you really need?

Rotating specials are available as well, so a seasonal selection might be a pleasant surprise. Past offerings, like the Morning California, become an instant hit—to enjoy in the smallish dining room or out on the airy terrace. Pink-and-turquoise decor gives a playful quality to your meal, along with the Lemonade Maison served in a mason jar.

Pair any adult meal with a glass of wine, beer, or cider; and treat your sweet-toothed children to a slice of cheesecake or peanut butter milkshake.

It may seem strange to spend a Parisian meal dining on burgers, but these in particular will please the palate whether or not your brood needs a break from finer French cuisine.

Oh, and if anyone in the group needs to hit the toilet during your visit, perhaps you'll discover why the bathroom has its very own hashtag: #pee_n_why.

(Or you'll simply be appreciative for a clean place to wash up the kids.)

SQUARE
DU TEMPLE

3rd arrondissement

Ⓜ❸ Temple ❽ Filles du Calvaire
Ⓜ❸⓫ Arts et Métiers

This particular plot of land in the middle of Paris has a bit of a sordid past, complete with the forced removal of the Knights Templar in the thirteenth century, and a prison during the French Revolution. But nowadays you will find Square du Temple to be a charming host to greenery and gardens containing some seventy species of trees to stroll among.

For energetic children, there is a playground to enjoy, complete with slides and swings, although older kids might find the offerings a bit juvenile. Still, your little acrobats can practice their moves on the monkey bars or help younger siblings scale the rope wall.

Surrounded by lush greenery, the landscaping is purely picturesque—almost like stepping into an impressionist's oil painting.

Live music often spills from the gazebo, or you can simply listen to the sounds of the city as you lounge on the lawn and soak up the sun. A bit tucked away from most visitor-frequented sites, you can make like a local in this particular park, putting on your best Parisian impression and faking it till you fit in.

Consider grabbing breakfast or lunch from Marché des Enfants Rouges to enjoy picnic-style (no alcohol allowed) on the sprawling grassy lawn. You might have the chance to join in on a bit of tai chi; or grab a paddle and challenge the gang to a ping-pong playoff. With any luck you'll find the perfect park bench to rest your tired toes, or an open, oversized board for chess and checkers.

Before you journey onward from your carefree encounter with Le Square du Temple, you might happen upon a very special plaque on the main lawn. Here you can take a somber moment to honor the cherished memory of eighty-five children whose lives were lost, long before their time, after each one was taken to Auschwitz during World War II.

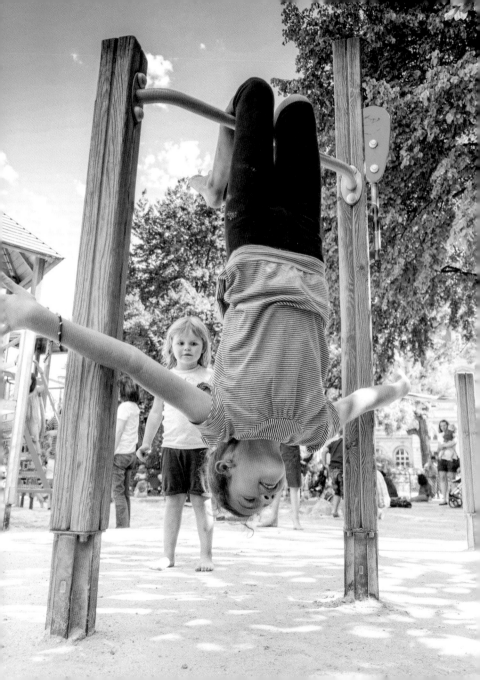

MARCHÉ DES ENFANTS ROUGES

3rd arrondissement
39 rue de Bretagne

Ⓜ❸ Temple ❽ Filles du Calvaire
Ⓜ❸⓫ Arts et Métiers

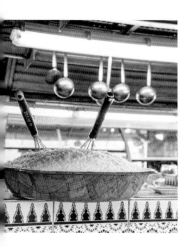

When everyone in the family is in the mood for a little something different, make your way to this vibrant, smallish market for a variety of cuisines to tempt any palate.

Whether you have adventurous eaters ready to try Moroccan or Lebanese, or tamer taste buds looking for fresh fruit and a bite of fromage (cheese), this stop for scrumptious food will not disappoint.

You can sit down for a morning or midday meal, or just pick up a few groceries to snack on throughout your day. Although just perusing the aisles will likely encourage your appetite to activate, so you may not make it farther than Le Square du Temple (page 40) before sampling from your stash.

If a warm crêpe oozing with delicious Nutella sounds right up your alley, you won't be the only one. The popular stand preparing them on the spot often has quite the line, and little ones might not possess quite enough patience to endure the queue.

Luckily, plenty of sweets and treats are ready and waiting to purchase and enjoy. Find a glass of wine, homemade truffle pasta, or perfectly ripe produce to satisfy your stomachs.

Partially covered for rain or shine, you might not be the only patrons escaping the elements, as locals and tourists alike collide in this tucked-away foodie forum. Rows of stunning flowers live inside this market as well, so if you have a friend to visit in Paris, pick up a fragrant bouquet or vintage photograph as a charming gift for the host or hostess.

And if you're wondering about this market's moniker, let the mystery be solved: its name hails from the sixteenth century, when red clothing was donated to children living in the orphanage on this spot.

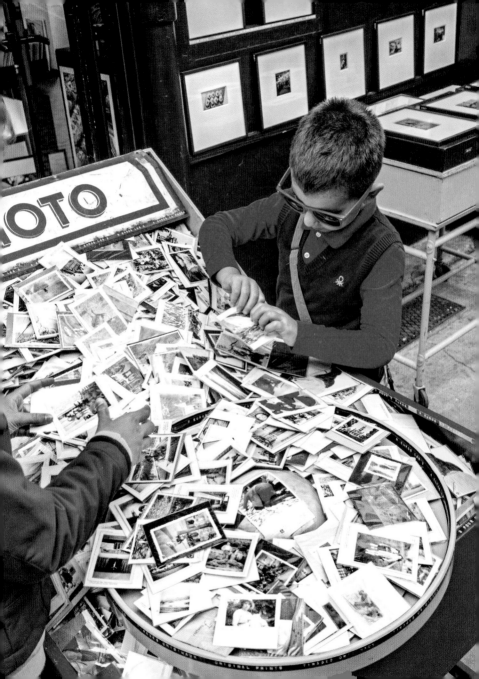

LE PROGRÈS

BRASSERIE

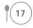

3rd arrondissement
1 rue de Bretagne

Ⓜ ❽ Filles du Calvaire

Situated at the corner of the rue de Bretagne near Le Square du Temple (page 40), this charming, typical Parisian bistro will fulfill your French fantasies of flavorful fare and cozy accommodations. Enter under the awning, and choose whether to dine inside or out. Spring and summer days will tempt you toward a table al fresco, where you can observe the hustle and bustle of Marais from the safety of your sidewalk spot, soaking up an inexplicable energy vibrating through the crowds.

Otherwise you'll find plenty of comfort within, should you choose the brightly lit interior all decked out in wooden furniture and golden accents.

A menu fit for man and beast (aka your rambunctious and ravenous children) offers a safe selection of tried-and-true favorites. The croque-monsieur (grilled ham and cheese) has that crunchy, golden appeal, and the steak arrives perfectly cooked. Relax with a glass of wine or cold beer to pair with a fromage platter prepared for the grown-ups.

Stop in for breakfast to start out your day with coffee and a croissant, or cap off an excellent afternoon with dinner and dessert. Perhaps a chocolate macaron, crème brûlée, or the highly recommended strawberry tarte will satisfy your sweet tooth.

The real appeal—apart from the favorable predictability of this conventional brasserie—is the owner's kind attitude toward children. On any visit to a new and unfamiliar city or country, a little friendliness to your tiny tykes can go an awful long way in keeping your holiday happy.

With a little practice of your French phrases, you may even go somewhat unnoticed as tourists in this brasserie largely populated by residents. Blending in will give you insight into honest interactions with a snapshot of local culture.

BREIZH CAFÉ

3rd arrondissement
109 rue Vieille du Temple

www.breizhcafe.com

Ⓜ① Saint-Paul
Ⓜ⑧ St-Sébastien - Froissart

It may have a queue, it may be a rather small interior, but you *will* be pleased with the delectable dishes you find at Breizh Café in this Marais eatery.

For something savory, order from their selection of crispy galettes, including a variety of ingredients. Melty Gruyère, salty meats, and perfectly cooked eggs fill these square-shaped snacks with a burst of flavor. Basic ham and cheese might prove just the trick for youngsters with an eye for more simple selections.

Save room for something sweet, and order a warm caramel crêpe with bananas and ice cream, or even a basic brown sugar and butter, to make for a full family of happy tummies.

Their artisanal ciders also come highly recommended to quench your thirst, or a simple cup of coffee pairs nicely with dessert.

If you know you'll be in the area, it might be wise to call ahead for a reservation, as seating is extremely limited. Then again, a spur-of-the-moment stop-in might prove lucky, or there's always the takeaway store next door, which serves many of the same menu items. Chic and sophisticated, the stone-and-wood decor of the Breizh Café makes for a savvy sense of style as unique and memorable as the food the kitchen serves.

PINK FLAMINGO
PIZZERIA

3rd arrondissement
105 rue Vieille du Temple

www.pinkflamingopizza.com

Ⓜ❶ Saint-Paul
Ⓜ❽ St-Sébastien - Froissart

This popular pizza joint has spread from its origins on the rue Bichat to three other locations in Paris, as well as a branch in Valencia, Spain. No matter which French location you're near, you'll want to stop in for a hot pie with any number of eclectic toppings.

Feeling particularly American, specifically Hawaiian? Order the Obama pizza, which features bacon and pineapple chutney. Or for figs and goat cheese, choose the Brangelina special. With wine and beer on the menu, as well as vegetarian and more basic selections for picky eaters, this joint can't miss for pleasing the whole family.

Your youngsters might prefer a simple mozzarella-and-tomato-sauce combination, which they'll enjoy while you dine on something a little more daring.

If you're eating in, the spunky decor provides an added bonus to your dining experience, with its black-and-white checks, multi-colored seats, animal-print upholstery, and, of course, any number of pink flamingos. In fact, if you have a little time to kill while you wait for the grub, challenge the kids to count how many instances of the signature bird they can find, and then ask your server if he knows the answer.

Or just sing along to the great soundtrack of rocks hits playing in a steady stream.

If you stop by to place an order on the rue Bichat, but decide you'd rather dine outside by the banks of the Canal Saint-Martin (page 194), the friendly staff will provide you a bright pink balloon to take along. That way they can easily spot where you've settled and deliver your piping hot pizza right to you. They also recommend feeding any unwanted crust to the French ducks.

Of course if you happen to be lodging nearby, having your dinner delivered by bicycle is a convenient option to consider as well.

MUSÉE DE LA CHASSE ET DE LA NATURE

MUSEUM OF HUNTING AND NATURE

3rd arrondissement
62 rue des Archives

www.chassenature.org

Ⓜ⓫ Rambuteau
Ⓜ①⓫ Hôtel de Ville

This quirky museum celebrates the strong tradition of respectful hunting practices, but you don't need to be a sportsman yourself to appreciate and enjoy the intriguing exhibits offered. Discover a new and unorthodox way to experience nature with collections of animals and themed artwork unique to this particular museum.

You'll find three overarching areas of interest to explore, making it easy to decide what best suits your family's curiosities.

In the Arms area, check out weapons and hunting tools dating back hundreds of years, including guns belonging to Louis XIII. Ornate hunting knives, carved crossbows, and royal weapons give the exhibit a historical appeal in addition to the draw of such intricately constructed tools.

Provided that no one in the group will be frightened by taxidermy, check out the collection of stuffed animals, ranging from a flock of birds to the fearsome wolf. And anyone standing under the mighty polar bear can appreciate that he won't be using his sharp teeth on passersby. Don't be alarmed if a mounted wild boar tries to strike up a conversation, or if you stumble upon a fox resting in an armchair.

When else can you get this close to a fierce feline without fearing those fangs?

An impressive gallery of artwork adds to the collection, with a ceramic pooch by Jeff Koons, and paintings depicting nature and hunting scenes by well-known artists like Peter Paul Rubens.

Temporary exhibitions round out the offerings at this site; and you'll want to keep an eye out for evidence of the existence of unicorns.

The eclectic atmosphere of this stately locale provides a nice departure from more well-known museums, with exhibits to uncover that you might never have even known you were seeking.

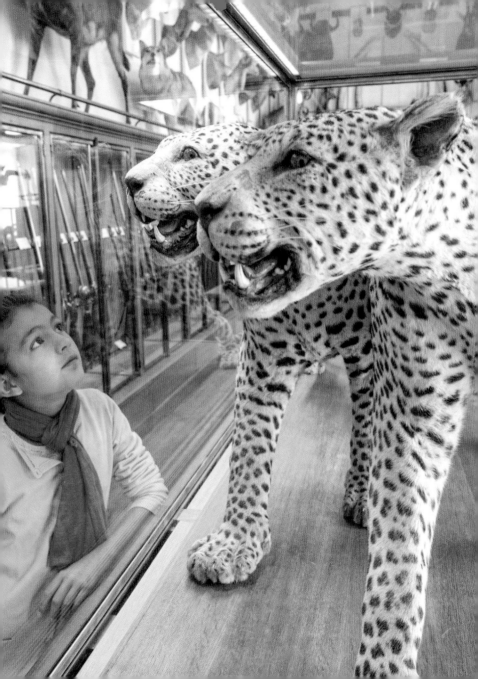

MUSÉE CARNAVALET
CARNAVALET MUSEUM

3rd arrondissement
16 rue des Francs Bourgeois

www.carnavalet.paris.fr

Ⓜ❶ Saint-Paul
Ⓜ❽ Chemin Vert

Simply walking around the city, you can begin to soak up the sense of rich history pouring out of the architecture, the traditions, and the very avenues you're strolling through. But to further explore the cultural background of Paris, a visit to the Musée Carnavalet will reveal artworks and relics of the city spanning hundreds of years.

Discover precious items dating back to a time when Paris was simply a village by another name (Lutèce), including sculptures and tools, or artifacts from even earlier, during prehistoric times. A wooden fishing canoe has been somewhat pieced back together from around 2700 BC.

Take a chronological journey through time if you like, making stops in the periods you find most intriguing, whether it be vivid paintings from the French Revolution or the beauty of the mansion's interior itself. Any fans of novelist Marcel Proust? Picture him penning one of his greatest works as you get a glimpse of his reconstructed bedroom.

Fortunately, placards for select exhibits are presented in multiple languages, so you might be able to learn a bit in addition to admiring the visual riches of each adorned room. Take advantage of available audio headsets to further enhance your historical education. The charming grounds, including a few sculptures, make for a breath of fresh air before or after your time inside, especially if your kids are tired of being told not to sit on the extravagant furniture.

Enjoy free admission for anyone seventeen years and younger, and pay a small donation fee for adults.

Note: Extensive renovations have begun on large portions of the museum, so you may want to inquire as to what percentage of the place is open if your visit falls before late 2019.

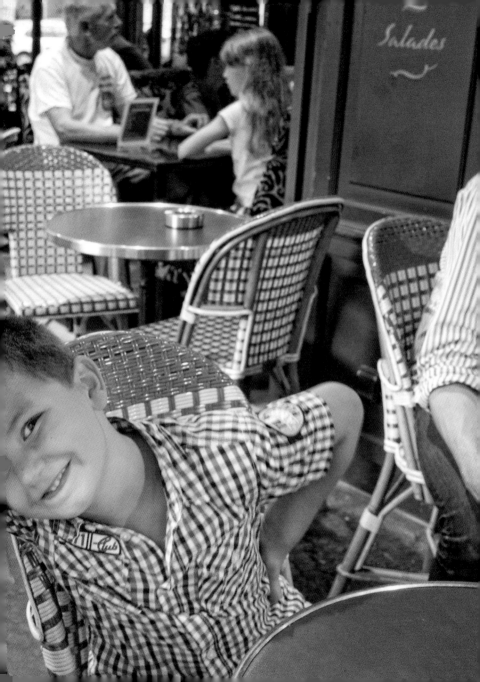

MOSAÏQUE

4th arrondissement
15 rue Vieille du Temple

Ⓜ❸ Saint-Paul
Ⓜ❶❶ Hôtel de Ville

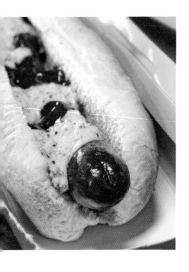

Is it a van, a metro car, a restaurant, or a little bit of all three? Tucked into the side of a building, with its deceptive sliding door, Mosaïque's little locale has the goods to appeal to your curiosity and appetite alike. Feeling a little homesick for American food? This hot dog stand is exactly the smallish spot for you, with its friendly proprietor, selection of toppings, and convenient location.

There's nothing especially gourmet about this experience, although crispy onions are an appealing topping option, and don't forget the free pickles. But if you're in need of a quick meal, a classic frankfurter might just be the way to go.

Thanks to their late hours, this tiny eatery may rescue you from the terrible fate of going to bed hungry if a tour runs over or you lose track of time. Popular among partygoers and pub crawlers, this quick snack can be the perfect accompaniment to the last beer of the evening—or provide a little sobering up as you stroll back to your hotel to turn in. (That is, of course, if you've found a suitable babysitter for the evening before imbibing.)

Named for the artwork adorning the exterior of this locale, the vibrant, multi-colored tiles feature depictions of swirling hues amid intertwined limbs. With no place to sit inside, you can take your bite to go, perhaps just a few steps outside to consider the beautiful facade.

CAFÉ SUÉDOIS

3rd arrondissement
11 rue Payenne

paris.si.se

Ⓜ① Saint-Paul
Ⓜ⑧ Chemin Vert

Visit this conveniently located café in Marais for the Swedish food and the charming atmosphere. Outside, the courtyard seating offers a delightful al fresco setting to enjoy your slice of carrot cake, your cup of brewed coffee, and your fresh bread. Often quite crowded, you may not get a table if your group is large, but perhaps luck will be on your side and you'll snag a spot to enjoy your traditional Swedish cinnamon bun. And if the delicacies offered make an especially positive impression on you, pick up a copy of their very own cookbook or a jar of their elderflower syrup to take home.

LE ROYAL TURENNE
BRASSERIE

3rd arrondissement
24 rue de Turenne

menuonline.fr/royal-turenne

Ⓜ① Saint-Paul
Ⓜ⑧ Chemin Vert

With its large sidewalk patio and quintessentially French decor, you'll feel right at home—even so far from your abode—when you grab a table al fresco at Le Royal Turenne. Near the Place des Vosges, in the middle of Marais, this Parisian café welcomes you at any time of day for whatever meal or snack you seek. This casual brasserie offers a wide selection of cuisine, from scallops and quiche Lorraine to caprese salad, chocolate crêpes, and crème brûlée. And of course, if you've worked up the nerve to try escargot, it's on the menu here as well.

As you settle at an outdoor spot, you'll be promised the most prime people-watching at this busy intersection of city life.

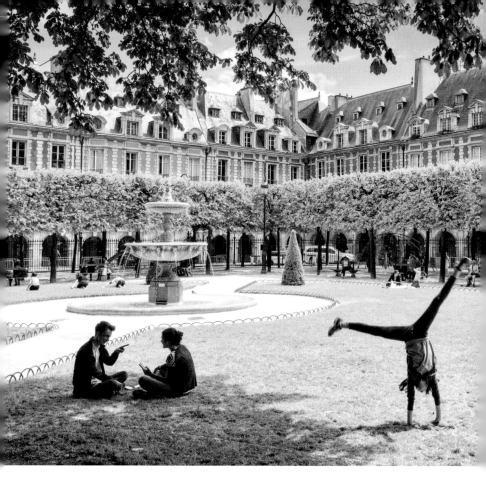

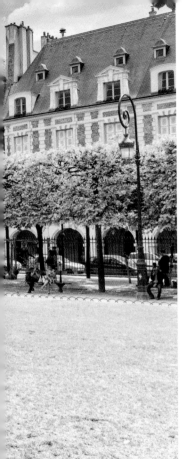

PLACE DES VOSGES

This charming square, dating back to the early 1600s, is the oldest of its kind in Paris.

It now serves as an attractive spot to lounge in the grassy park in the shadow of a statue or leafy green tree, surrounded by four walls of picturesque, identical buildings. Or you can stroll along under the lowest-level arches, seeking shopping and refreshments. Locate lunch in any number of cafés, and dine out in the fresh air in the shade of the arcade.

Here, locals and tourists will mix, whether or not it's desired, in an effort to find a snack or visit one of several art galleries.

A children's play area provides a welcome outdoor break for your youngsters to run and stretch their legs, as you take a rest of your own and admire the park's symmetry and architecture. If you're lucky, you'll hear live music from local talent—or simply the soothing trickle of a fountain—to enjoy as you nibble on a fresh baguette.

The Place des Vosges has boasted a few notable residents in its recognizable red-brick perimeter, including Victor Hugo for more than fifteen years. Now open for visitors to enjoy, this particular House of Victor Hugo features re-creations of rooms from various periods in his life, including a personal, curated collection of art and decor.

Before leaving the square, you might want to search out a small private door to access the gardens of the Hôtel de Sully, and continue on through another passageway to find a courtyard of sculptures. Some stumble upon this secret garden quite by accident, but however you come across the hidden gem, you'll be glad to stroll through.

4th arrondissement

www.parisinfo.com

Ⓜ① Saint-Paul
Ⓜ⑧ Chemin Vert
Ⓜ①⑤⑧ Bastille

PLACE DU MARCHÉ SAINTE-CATHERINE

4th arrondissement

Ⓜ① Saint-Paul
Ⓜ①⑤⑧ Bastille

A bird's eye view of this section of town reveals a smallish square of lush green amidst a sea of gray roofs. This largely pedestrians-only spot provides a simple respite from the city's hustle and bustle. Lined with trees, and mostly closed off from vehicles, to find yourself in Place du Marché Sainte-Catherine is to find yourself in an idyllic Parisian moment.

If the weather is nice (and the smokers aren't too numerous), you'll want to find an outdoor table to sit for a spell, sip on a coffee or soda, and soak up the welcome sunshine. Perhaps Chez Joséphine will have a spot for you to enjoy their beef bourguignon or Grand Marnier soufflé.

If you speak French—or the language of illusions—you can head inside Le Double Fond for a little mystery and magic with your meal.

Otherwise try your luck with an outdoor seat at La Terrasse Sainte Catherine—cheeseburgers for the kids, mussels for the adults—or Au Bistrot de la Place. Under this stripey awning you'll find a delicious bowl of French onion soup or a plate of steak frites.

Although, if you're strolling through the square between meals, you can still partake in admiring the atmosphere. Sit the family down on a park bench to chat about your vacation so far and rest your legs a bit before heading off to the next adventure on your list. If luck is on your side, some talented local musicians may serenade your stop.

And should the kids have a bit more energy to expend than the older crowd, consider letting them run and play a bit in the open square, away from the busy city streets and restrictive museums. Of course, if hordes of locals are enjoying the nice weather like yourselves, the youngsters will have less space to stretch their limbs within eyesight.

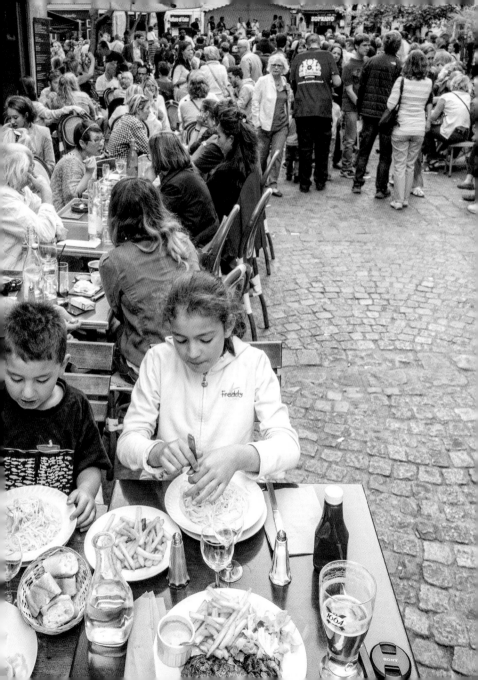

L'ÉCLAIR DE GÉNIE
PASTRY SHOP

4th arrondissement
14 rue Pavée

leclairdegenie.com

Ⓜ● Saint-Paul

Transforming a traditional French pastry into something new and tantalizing is the genius of the owner—Christophe Adam—of L'Éclair de Génie. The éclair is a favorite dessert dating back to the nineteenth century, but these particular pastries aren't your tired treats of yesteryear. Rather this delicacy has been reinvented in a vast variety of flavor combinations to surprise and delight hosts of salivating patrons.

Choose from the Praliné Noisette (hazelnut and praline), the Choco Coco (crispy milk chocolate with coconut cream filling), or the green apple vanilla, among many others.

Most are too detailed and beautiful to eat, so you'll have to decide whether to frame it or eat it (choose the latter!). And the decorations aren't limited by conventional methods; fancy yours with a photo of angelic cherubs or a message of love printed in icing? It might be your lucky day.

And if éclairs are not your dessert of choice … you might be wrong. Just consider giving them another try, perhaps with the berry option sprinkled in edible gold. Or, if you're steadfast in your disapproval, you can peruse a selection of wrapped candy bars and bonbons to save a sweet snack for later.

The decor, not unlike the updated dessert, is quite modern, differing from your usual cozy bakery feel, but one glimpse of the vibrant varieties through the shop window will lure you in.

Éclairs run about five to six euros each, so choose your flavor carefully—or splurge on one of every option. With no tables inside to enjoy your treats, you'll want your next destination in mind: someplace you can rush to and get down to the business of eating.

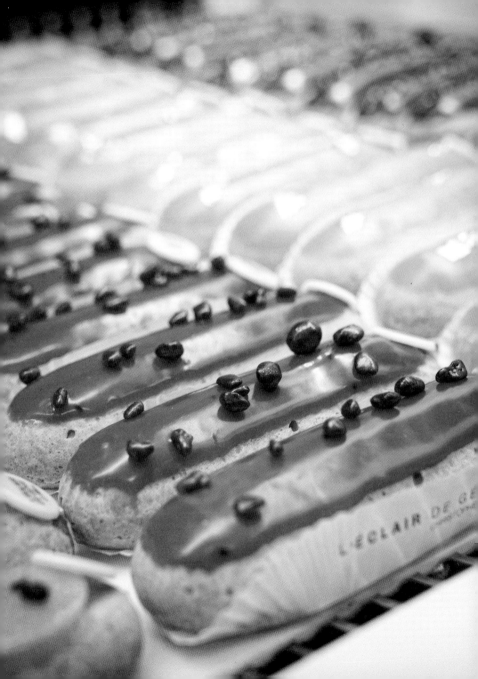

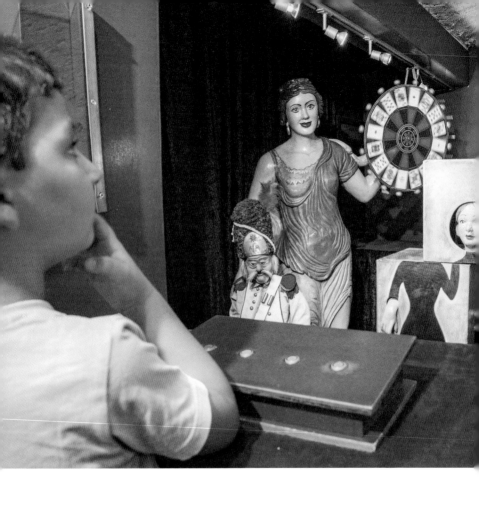

MUSÉE DE LA MAGIE
MUSEUM OF MAGIC

28

A little bit of magic is exactly what the entire family needs on vacation, whether you're six, sixteen, or sixty. At the Musée de la Magie, find the enchantment of three centuries of illusions as you venture past odds and ends of the magician's trade.

Enjoy a show performed by a skilled charmer, and don't worry if French isn't your native tongue; most of the tricks are easy to understand in any language. Don't be shy about asking for a translation when the time is right; the friendly staff will do their best to improve your experience. Of course they can't give away any trade secrets of their craft, so you'll be on your own to dissect the riddles of their illusions.

The building itself will add to the ambiance of your visit as well, as you stroll under low, stone archways in the cellar below the home of Marquis de Sade. You'll see magic mirrors, a magician's secret tools, and even a couple of items that belonged to Houdini himself. After you spend an hour or so in this quirky museum, you may decide to journey next door to the Musée des Automates to check out quirky, button- and coin-operated machines, like cymbal-playing monkeys and a slew of other strange characters.

Your trip won't be complete without checking out the museum gift shop if you have any budding illusionists among your flock. Youngsters can pick up a trick of their own to practice and perfect before wowing everyone back home with their expertise.

4th arrondissement
11 rue Saint-Paul

museedelamagie.com

Ⓜ① Saint-Paul
Ⓜ⑦ Sully - Morland

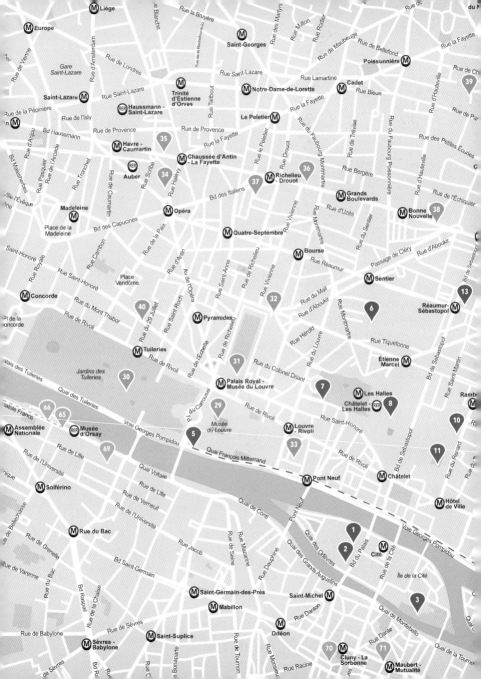

MUSÉE DU LOUVRE
LOUVRE MUSEUM

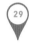

1st arrondissement

www.louvre.fr

Ⓜ ❶ ❼ Palais Royal - Musée
du Louvre

If you're anything like the (more than eight million) people who arrive at this destination each year, you've been waiting for and anticipating this particular day for quite some time: your first visit to the Musée du Louvre. The *Mona Lisa* (she's smaller than you think!) is right inside, along with Venus de Milo, Leonardo da Vinci's *Virgin of the Rocks*, and a personal favorite: *Psyche Revived by Cupid's Kiss*.

Hopefully you've worn your best walking shoes, had a peaceful night's rest, and carved out a significant chunk of your day (if not the whole thing) to explore and discover the expansive collections of one of the world's largest museums. You'll be in a race against time—whether it be the museum's hours, your children's attention span, or your own fading energy levels—to make it to every painting and sculpture on your list of must-see artworks.

The fun begins before even stepping inside, as you first happen upon the imposing facade: a controversial juxtaposition of the contemporary glass pyramid, and its fountains, nestled before the former fortress. A sense of history and importance radiates from the ground itself as you walk toward the transparent triangle entrance, knowing the vast contingent of masterpieces that lies within.

At more than two hundred years old, with more than 35,000 pieces displayed (and an additional treasure trove of some two hundred thousand hidden away), and 650,000 square feet of space to tread, the numbers alone are enough to intimidate a fearsome family like your own. But with a game plan in place, whether it be a checklist of favorites or a calm penchant for casual browsing, your day can be an enjoyable opportunity for a little artistic admiration.

Even the kiddos will find a few things fascinating, with a little careful consideration of their current

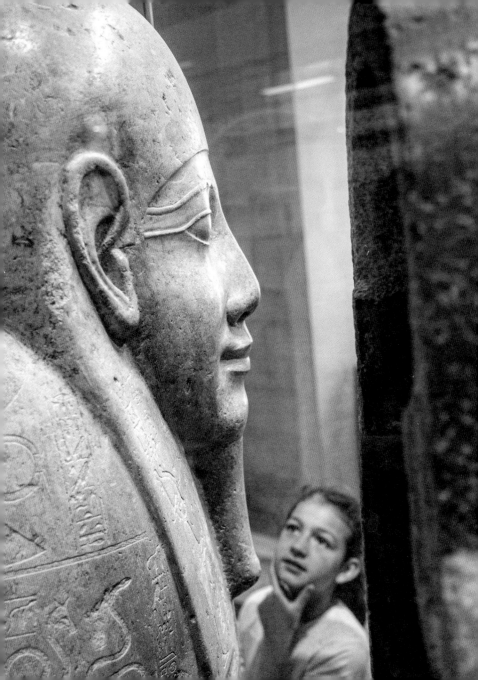

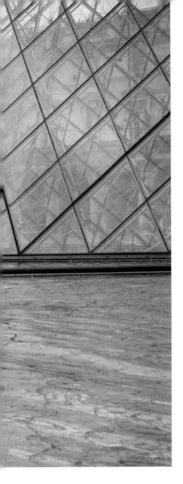

interests. Perhaps the mighty history of the fortress itself, with its very own moat, will peak the curiosity of your little prince or princess. Or your youngsters may appreciate the magnificence of the Louvre's outdoor offering: the Tuileries Garden. Even the eerie past of a nearly empty museum during World War II will enthrall any history buffs in the group, young or old.

Then again, the breathtaking beauty of each avenue of artworks could simply be enough to entertain all the birds in your flock, with every imaginable subject matter, and a time span of sixth century BC to the nineteenth century AD. Are your youngsters brave enough to face the shrouded mummy? Intrigued by intricate impressionists? In awe of Napoleon's gilded and lavish apartments?

You might be pleasantly surprised (or possibly horrified) at the details your children observe in the dramatic sculpted figures, Egyptian antiquities, and painstaking oil portraits. And even the knowledge they already have (whether accurate or distorted) from movies, TV shows, and other pop culture references might influence their impressions or lead them to learn more about particular pieces.

Be prepared to get to know your neighbor near the most popular pieces—*Mona Lisa*, for instance, usually has quite the crowd surrounding her famous frame (behind bulletproof glass), including a couple of security guards.

If anxiety for a full family visit is still haunting your dreams, you may consider easing your admission by trying out an alternate entrance—check out the Porte des Lions or the underground mall (Galerie du Carrousel) adjacent to the metro stop.

Another appealing activity for your kids is a rentable audio guide operating on a Nintendo DS—in other

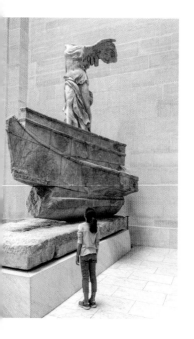

words you're handing your child a video game to play as they wander about. What could be better? The guide also has optional built-in tours in case you want to see the museum-chosen highlights or other themed suggestions. A smartphone app is available for complimentary download as well.

Need a break for lunch? Take advantage of the museum's multiple cafés and restaurants, or hang on to your tickets for a picnic in the park. Regroup over an energizing meal, and head back into the galleries with renewed excitement. But don't expect to make it to every marvel within these walls—unless you have approximately nine months to spare.

Admission is free for anyone under eighteen years old, and you can purchase adult tickets online beforehand to cut down (if not eliminate) your wait time upon arrival. (Or simply whip out your Paris Museum Pass.) This planning ahead might be just the time to start talking up the museum's offerings. A little advance enthusiasm could set your kids on a more positive path before the day begins.

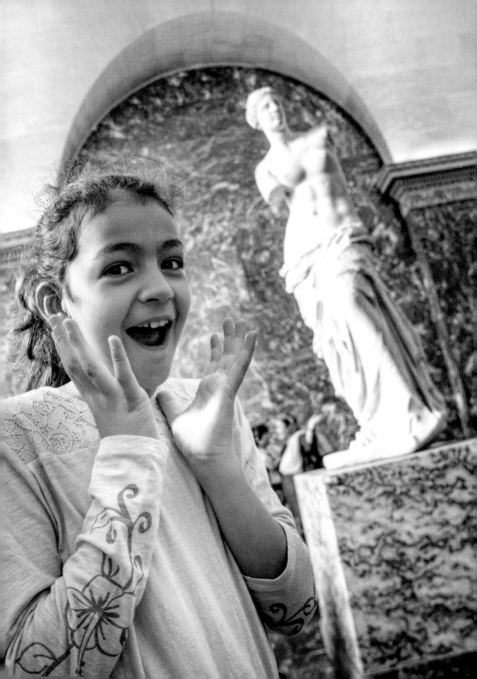

JARDIN DES TUILERIES

TUILERIES GARDEN

1st arrondissement
113 rue de Rivoli

www.parisinfo.com

Ⓜ① Tuileries
Ⓜ①⑧⑫ Concorde

Betwixt the Louvre and the Place de la Concorde, find the Tuileries Gardens, named for the tile factories that resided on these grounds prior to 1564. In that year Queen Catherine de' Medici commissioned the Tuileries Palace, and the expansive and stunning gardens have existed in multiple forms ever since (including its current layout since 1664).

With a historic collection of statues spanning centuries, as well as breathtaking ponds and fountains, there are plenty of visual riches to enjoy, even beyond the collection of greenery and colorful bouquets of flowers that appear extensively throughout the park.

Of course, once the kids have had their fill of strolling among the trees and scampering in the wide-open spaces, they'll be keen to check out the other attractive aspects of the area. Specifically, the large

playground offers a slew of opportunities for your youngsters to run and play on the slides, the rope-and-wood walkways for children over six years old, the jumping platforms, the spinning merry-go-round, and the swinging hammocks.

And aside from the playground, there's an appealing area of mini trampolines for bouncing, or a classic, horse-filled carousel for riding—both available to enjoy for a small fee.

On Wednesdays and weekends, don't miss the pony rides for a close-up experience with nature's gentle creatures, as well as the opportunity to captain small, toy sailboats across the pond. Keep an eye out for ducklings as well, especially if you have any spare snacks on hand to share.

If you're up for a museum visit, step inside the Musée de l'Orangerie, within Jardin des Tuileries, to admire Claude Monet's *Water Lilies*, among pieces by other artists, including Picasso and Cézanne.

Traveling in summer? In July and August, you'll have the chance to explore La Fête Foraine, the garden's carnival, complete with a magnificent Ferris wheel, bumper cars, climbing walls, zip lines, and a host of sugary sweet fair foods.

If you're looking for a little souvenir of your day, stop in at the Tuileries Gardens bookstore to pick up a children's book about the grounds, or an art print of the beautiful area.

For a small cost, you can also gain admittance to the all-important attraction at the entrance near the Place de la Concorde: the very necessary and fairly clean bathrooms. If a little pick-me-up is in order— particularly after a trip to the Louvre—visit the café on-site to grab a coffee and croissant.

PALAIS-ROYAL

ROYAL PALACE

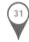

1st arrondissement
8 rue de Montpensier

www.domaine-palais-royal.fr

Ⓜ①⑦ Palais Royal - Musée
du Louvre
Ⓜ⑭ Pyramides

Just across from the Musée du Louvre, this Parisian palace—formerly the Palais-Cardinal—possesses a beautiful "village in the city" for your family to experience and enjoy. Housing a slew of various royalty for more than two hundred years, today the Palais-Royal hosts government departments as well as opening its gardens and courtyard to visitors. While a rich and varied history of political, cultural, and even scandalous affairs resides within the doors of this Parisian site, your group will find plenty to appreciate throughout its expansive grounds. Whether you're strolling through a long row of bright green-leafed trees or among the resolute columns of the palace walkways, your path will be peaceful and picturesque. Feel free as well to explore the restaurants and shops accessible to the public.

If you're looking for an upscale dining experience, the Michelin-starred Le Grand Véfour has resided at the Palais-Royal since 1784, and has served such notable guests as Victor Hugo and Napoleon Bonaparte. The elegant menu is quite pricey, so this might not be a realistic option for the entire family to enjoy. But don't fret if hunger strikes as you are photographing your stunning group with a palace or impressive fountain as backdrops—various café options will take care of that coffee and baguette craving. Window shopping at the designer boutiques might be all that the kids allow, but they should get a kick out of *Les Deux Plateaux*: an outdoor art installation of black-and-white columns of various heights, which make you feel like you're inside a complex game board. From start to finish, the Palais-Royal might not be a spot you *must* visit during your trip, but there will be no regrets if your family decides to check it out. Need a bathroom break? Try inside one of the cafés (purchase may be required) or seek out the public restroom near the entrance to the Palais-Royal metro station.

THE KIDS WILL GET A KICK OUT OF *LES DEUX PLATEAUX*: AN OUTDOOR ART INSTALLATION OF BLACK-AND-WHITE COLUMNS OF VARIOUS EIGHTS, WHICH WILL MAKE YOU FEEL LIKE YOU'RE NSIDE A COMPLEX BOARD GAME.

GALERIE VIVIENNE
SI TU VEUX TOY STORE

2nd arrondissement
4 rue des Petits Champs

www.galerie-vivienne.com

Ⓜ① Palais Royal - Musée
du Louvre
Ⓜ⑦⑭ Pyramides Ⓜ③ Bourse

Among the mosaic avenues and light-filled corridors of the Galerie Vivienne, you will find a vibrant children's store filled with new and antique toys alike. Whether it be the newest electronics that appeal to your youngsters, or the vintage, wooden favorites of your own childhood and before, the varied collection will surprise and excite. Cult classics abound, and you will delight in discovering games and gadgets you'd forgotten over the years.

Introduce kids to building blocks, darling dolls, and intricate tools for imagination, and you might have to pick up a souvenir or two to unlock new possibilities for play.

A pair of wooden bears will welcome you inside to explore each aisle of carefully curated selections. Find age-appropriate and well-designed options, which might be a nice change of pace from some of the other eye-catching trends that normally appeal to your bright-eyed brood.

It never hurts to sneak in a little learning to your children's daily playtime, and at Si Tu Veux you can find educational options mixed with truly joyful toys the whole family can enjoy.

Of course, while the kids are enthralled with an endless supply of entertainment, an adult or two can find a free moment to wander the remainder of Galerie Vivienne. Explore the elegant offerings of Abis, peruse the printed pages at the Jousseaume bookstore, or even sample a selection of wine at Legrand Filles et Fils.

When every family member has had his or her fill, you can come back together for traditional quality cuisine on the terrace of Bistrot Vivienne. If nothing else, the Berthillon ice cream on the menu will satisfy the sweet tooth of every shopper in your gaggle.

MUSÉE EN HERBE

CHILDREN'S MUSEUM

1st arrondissement
23 rue de l'Arbre-Sec

museeenherbe.com

Ⓜ❶ Louvre - Rivoli
Ⓜ❶❼ Pont Neuf
Ⓜ❹ Les Halles
Ⓜ❶❼⓫⓮ Châtelet

Self-proclaimed as "the only museum for three- to 103-year-olds," the Musée en Herbe has celebrated interactive art for more than forty years. Geared toward introducing and affirming art appreciation for children in a fun and humor-filled atmosphere, this museum creates opportunities for youngsters to enjoy a host of creative experiences.

Rotating exhibitions might feature illustrations of a beloved comic book character, or a celebration of the vibrant pop art of Andy Warhol. A recent offering displayed the work of Belgian cartoonist Hergé, including his most famous character: Tintin.

You can book a guided tour online to get the full scoop on the existing collection during your visit, or stroll around at your own leisure.

With opportunities for children to dress up, participate in a treasure hunt, play games, or listen in on story time, this location might not take up your entire day, but it'll certainly appeal to your youngest—especially if you opt to explore with one of the museum's animated tour guides.

If you know when you're visiting ahead of time, consider booking a workshop for your kiddos online. They'll be inspired to dream up works related to the main exhibit, or the whole family can pitch in to create a group masterpiece.

Don't be underwhelmed by the size of this attraction; your time will be what you make of it—participating in the puzzles and learning from the staff will extend and brighten your visit. Pick up an activity sheet, enjoy the English captions, and appreciate this unencumbered chance for pure play with your kiddos. Available restrooms and the little gift shop are two stops you'll want to make before heading away from this smallish museum.

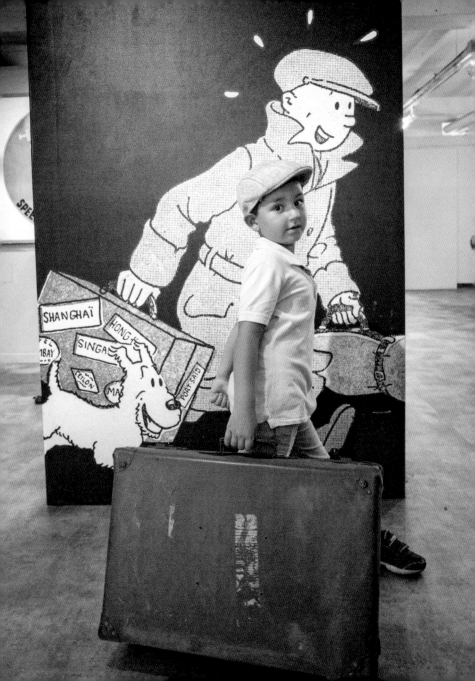

PALAIS GARNIER
OPERA HOUSE

9th arrondissement
8 rue Scribe

www.operadeparis.fr

Ⓜ❸❼❽ Opéra
ⓇⒺⓇⒶ Auber

With a facade as magnificent and majestic as the productions within, the Palais Garnier opera house certainly looks the part of an elegant Parisian performance hall. Its stunning and familiar exterior conjures up visions of royalty clad in floor-length gowns, VIPS seated in exclusive balcony boxes, and a pair of golden opera glasses perched on the nose of every audience member.

Completed in 1875, the structure is named for its architect (Charles Garnier) and boasts exterior ornamentation—created by a multitude of artists—including a pair of golden winged figures, countless columns, and a central sculpture of Apollo. Standing in front of the Opéra metro stop, you can catch your best all-encompassing view of the impressive building's architecture.

And yet walking inside proves to be as breathtaking (if not more so) as you encounter the Grand Staircase with all its ornate marble grandeur. As your group ascends, encourage your youngsters to crane their necks to take in the high ceiling, rows of chandeliers, and all that glistens within the Grand Foyer.

The brilliance certainly doesn't cease inside the auditorium itself. Here you can admire the painted ceiling by Marc Chagall, depicting various scenes from masterful operas. If your family has any fans of *The Phantom of the Opera*, you'll enjoy standing in the masked man's birthplace, where eerie incidents inspired Gaston Leroux to weave his fictional tale. Perhaps you're lucky enough to attend a performance of the Paris Opera or Ballet during your visit, in which case you'll experience the beauty of the Palais Garnier both onstage and off. But even if a tour is all that your schedule allows, it won't disappoint with its effortless elegance and undeniable appeal.

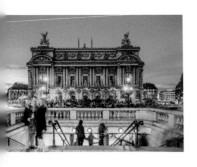

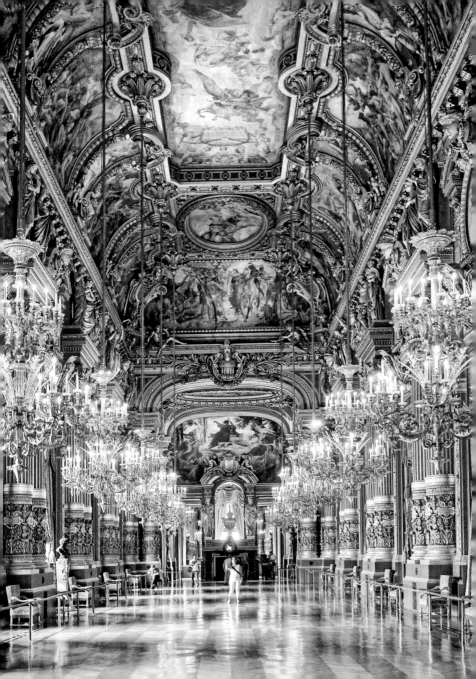

GALERIES LAFAYETTE
(HAUSSMANN)

35

9th arrondissement
40 boulevard Haussmann

haussmann.galerieslafayette.com

Ⓜ️ 7️ ⑨ Chaussée d'Antin -
La Fayette

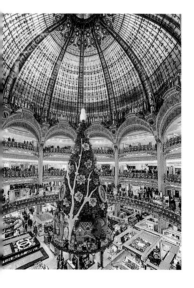

This chain of French department stores offers an upscale, elegant shopping experience with high-quality clothing, housewares, and gifts. Browse aisles and aisles of Parisian fashions at this flagship location, and you'll be dressing like a local in no time at all. Even your bébés will feel très chic after you pick out the best outfits for your youngest fashionistas.

Not usually sitting front row with Anna Wintour at Paris Fashion Week? Get a glimpse of the good life with the location's free fashion show every Friday at 3 p.m., and pick up a few tips from the trendy models walking the runway. (Online reservation required.) If you're traveling during the holiday season, be sure to visit Santa in his fifth floor grotto, where the kids can share with him their Christmas wishes.

Here you can also find the all-important toy department to entertain the youngsters with multi-colored Legos and beautiful books while others shop away.

Beyond the beauty of the fashion itself, you'll enjoy the elegance of the atmosphere with its ornate decor and glass-domed ceiling. You'll all feel fairly fancy and French as you consider a cashmere pashmina or chic chapeau (just no bérets) to wear out to your next Parisian dinner.

Of course luxurious items don't come cheap, and even a trip to the Galeries Lafayette bathroom may prove a bit too expensive. But browsing and basking in the brilliance of the towering Christmas tree should still be free, so don't skip a stop inside just because you're on a budget. In fact, a trip up to the rooftop terrace is worth the visit for even the anti-shoppers in your family group. Stop in at any one of the variety of dining options throughout the shopping center and grab takeaway burgers or dim sum before you ascend to enjoy up in the open air.

MUSÉE GRÉVIN
WAX MUSEUM

9th arrondissement
10 boulevard Montmartre

www.grevin-paris.com

Ⓜ️❽❾ Grands Boulevards

The Musée Grévin was made to be one continuous guessing game to test your children's knowledge of notable and celebrity figures, as you travel through the corridors of this wax museum. Beginning with the hall of mirrors and a sound-and-light show (which might prove a little bit scary for your youngest family members), your experience commences as soon as you arrive at this extravagant building.

Once you've gained admittance into this home to more than 400 figures, you'll encounter myriad themed collections of characters to meet and cozy up to. Some cultural contemporaries will appear, from fashion's Christian Dior and Naomi Campbell to opera great Luciano Pavarotti.

Brilliant architecture and decor highlight your visual journey, with ornate columns, detailed arches, and vaulted ceilings serving as more than a backdrop. French athletes stand tall with team uniforms and game faces on, and in the Discovery Tour area, your group can touch and feel the materials that make up these mysterious creatures.

Of course, the children's area will most likely be the biggest hit of your visit. Here the kids can get a glimpse of some of their favorite characters of film and literature—you might meet a superhero like Spiderman or a silly squirrel like Scrat from "Ice Age." And your photo ops won't be complete without posing next to the Queen of England, Albert Einstein, or Leonardo da Vinci. Will your youngsters recognize George Clooney or Penelope Cruz? Or perhaps these and other particular celebrities will prove more appealing for swooning adults.

Some French figures might not be familiar, but perhaps you'll discover some new faces to find in history, film, and pop culture when your trip concludes. Admission is a bit on the pricey side, so check your budget (or use the Paris Museum Pass for a discount) before committing to a visit.

PASSAGE DES PRINCES

JOUÉ CLUB TOY STORE

37

2nd arrondissement
5 boulevard des Italiens

www.parisinfo.com

Ⓜ❽❾ Richelieu - Drouot

The architecturally beautiful Passage des Princes houses an elegant department store beneath its glass-roofed archways. Yet sans those pesky housewares and endless racks of grown-up clothing, the Joué Club isn't your typical retailer but rather a collection of themed toy stores together in one convenient locale for maximum childhood excitement and a hankering for something from each and every spot.

Whether your youngsters are into Legos or Barbies, Hot Wheels or board games, there's an abundance of options for everyone in the family—at least everyone who can still be called a kid (and maybe even the kids at heart).

Self-proclaimed as the largest toy store in Paris, it seems only natural that your family might find the time to explore this vibrant village perfect for your pint-size shoppers. With nearly 22,000 square feet of space, and fifteen individual storefronts, your family can find a cuddly plush friend or a wooden building set, and perhaps your kids will discover a new type of toy they'd never even considered.

Of course if your suitcases aren't equipped to handle an excess of souvenirs, then you might want to set some buying limits before stepping inside. Still, even the adults will appreciate the impressive walkways and niche offerings stocking each shop.

Any of your children looking a little shaggy on your overseas adventure? Stop in at the children's hairdresser for a quick trim.

In addition to the checkered floor and ornate decor, don't miss the stained-glass rotunda within the renovated Passage des Princes, which was first built in 1859 and became home to the Joué Club Village in 2002. The appeal of the light-filled corridor will certainly enchant adults in your party, but ultimately it will be the endless array of games and toys that make it difficult to tear the kids away.

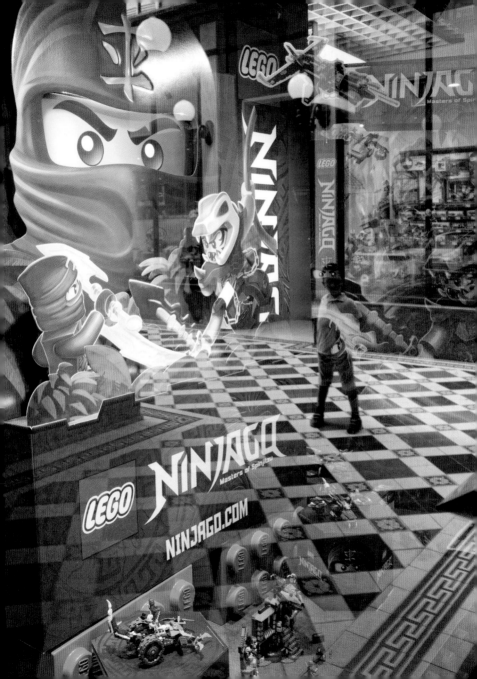

LE MUSÉE GOURMAND DU CHOCOLAT
THE GOURMET CHOCOLATE MUSEUM

10th arrondissement
28 boulevard de Bonne Nouvelle

www.museeduchocolat.fr

Ⓜ❽❾ Bonne Nouvelle

A bit of history, a bit of a cooking lesson, and a bit of silky smooth goodness to taste and enjoy awaits your family at this bite-size museum dedicated solely to gourmet chocolate.

Three levels of Choco-Story introduce visitors to the rich and delectable history of chocolate, teasing your taste buds for the final piece of your tour. Your youngsters might need a little extra incentive for patience, so the museum provides a sticker scavenger hunt to complete—including a prize at the end—as they make their way through the tour. Of course, a steaming cup of Aztec hot chocolate may do the trick just as well.

Journey back more than four thousand years ago to the first known use of cocoa by the ancient Mayans, and continue on to a time when it was thought to be the "divine nectar" of the gods, as well as a method of payment. You'll learn how the simple and delicious treat has changed and evolved over hundreds and thousands of years to become the favorite dessert we know and love today.

The end of the tour is sure to offer the sweetest reward, as you watch a demonstration, listen to candy-making tips, and taste the final, high-quality chocolate samples. You may want to take note of when demonstrations are occurring upon first arriving, so you don't have to wait around for this aspect of your visit once you've finished checking out all the exhibits. Your final stop will be the museum gift shop—best of luck making it out without scooping up a few flavors for the family to share! You'll be pleased that several aspect of Le Musée Gourmand du Chocolate are presented in English, and if you have a Paris Pass (different from the Paris Museum Pass), this museum is included, so check that out ahead of time.

LE MANOIR DE PARIS
HAUNTED HOUSE

39

10th arrondissement
18 rue de Paradis

www.lemanoirdeparis.com

Ⓜ⑧ Poissonnière
Ⓜ❹ Château d'Eau

Is your family among the bravest of the brave? You'll all need to be in order to conquer and survive a visit to Le Manoir de Paris—a haunted show and interactive tour in the heart of Paris. All ages are welcome, but the experience is not recommended for children under ten years old (or twelve years old around Halloween). Even as you queue, a host of monsters will attempt to intimidate you, warming you up to the dangers inside.

This spooky spectacular takes you inside the (faux) Catacombs of Paris, to the crocodiles of the city's sewers, and within reach of bloodthirsty vampires. Don't be surprised to appear in a cemetery or meet a vicious witch, but just remind yourself and your group that none of the scary characters are allowed to actually touch you, thankfully.

Just when you think you might have found your escape, you'll be admitted into the maniacal, medical grasp of the Asylum to complete your terrifying trip. Le Manoir de Paris is only open Friday through Saturday, so plan accordingly, and beware if you book and print your tickets online ahead of time: no refunds are given to 'fraidy cats who are scared off before your scheduled stop-in.

Bonus: the tour is offered in English, as well as French, so be sure to ask for your preferred language between the two before your journey begins. Toilets are only available at the end of tour, so take care of business before you arrive. You won't want anyone to be in danger of accidents when creatures undoubtedly hop out of their hiding places.

COLETTE
DEPARTMENT STORE

1st arrondissement
213 rue Saint Honoré

www.colette.fr

 Tuileries
Pyramides

Bright and inviting in its modern elegance, this three-level department store presents a vibrant atmosphere to shop and indulge in the delights of Parisian retail. Whether you're looking to put together the best of France's fashions for your family's forays around the city, or accessorizing an already otherwise chic ensemble, the women in your troop will appreciate the collections at hand. Of course menswear is readily available as well, so the stylish gentleman will find plenty to peruse among the racks of designer brands. Or pick up a new scent to enhance your memories for years to come with a selection of fragrances, lotions, and skincare in the Beauty Box.

If glass cases of upscale jewelry, including diamonds and precious stones, aren't part of your travel budget, you can stick to the ground floor for your shopping interests. Here you'll find all manner of offerings for your gifting needs—even if the gifts are just for you and your brood of tiny travelers. From books, magazines, and movies to candles, sunglasses, and the latest gadgets to tempt tech-savvy tykes, it's an appealing assortment.

Prefer a little artwork while you browse? Take a gander at the Colette gallery to take in the month's temporary exhibit of a chosen highly respected artist. When the shopping wears you out—or certain family members are taking a bit too long in the dressing rooms—make your way to the basement to refuel in the Water Bar restaurant. Whether you're seeking a simple cup of coffee or a plate of truffle risotto, you can find a snack, brunch, or lunch to fit into your day. Free Wi-Fi is available here as well, so take advantage if you need to plan your next destination or check the metro map; and don't forget to use the restaurant restrooms before you depart.

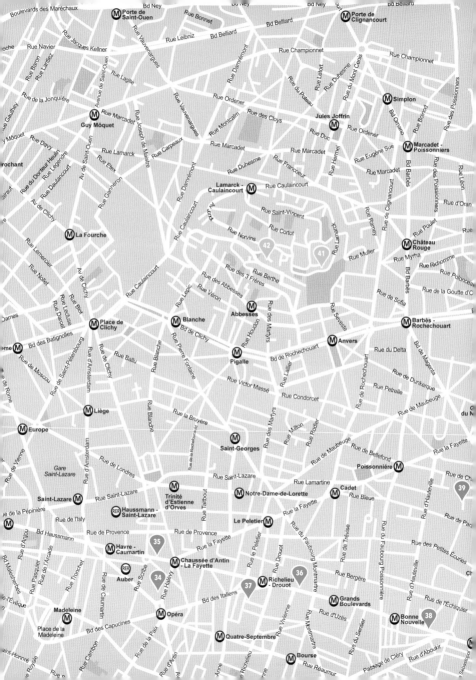

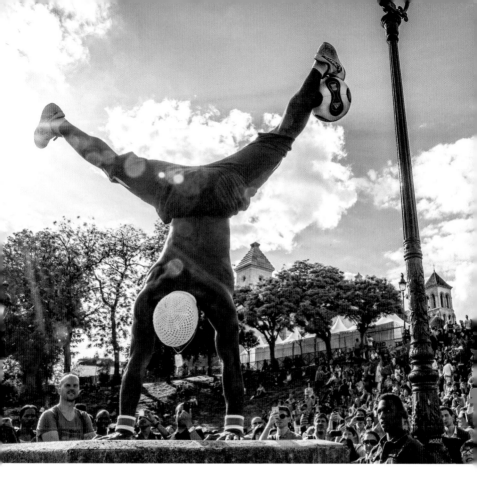

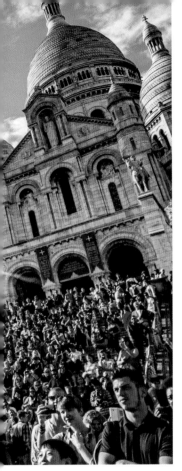

SACRÉ-CŒUR
SACRED HEART BASILICA

No doubt one of the spots you've been dreaming of visiting, it might be slightly more difficult to get the kiddos on board with a trip to a beautiful church at the top of a hill. Perhaps a funicular ride up to the base of Sacred Heart Basilica of Montmartre will start things off on the right foot. It's a short, ninety-second trip, but at the price of a metro ticket, it can save little legs from climbing more than two hundred steps, conserving energy for the stairs after exiting the funicular, or those inside the basilica if you choose to ascend the dome. Situated at the highest point in Paris, take a moment outside Sacré-Cœur to take in stunning views of the city for miles beyond. Admission to the church is free, with just a small fee (it varies) to climb the Dome or explore the Crypt. If you choose to take advantage of further expansive vistas from the height of the Dome, you'll need to conquer three hundred stairs. But once at the top you can catch your breath as you "Ooh" and "Aah" at the Parisian skyline laid out before you. Venturing down to the Crypt, you'll find a quiet reverence away from the city's bustle, and there—as well as inside the main church—you'll find exquisite statues and architecture that match the beauty of the church's white, bleached exterior. Don't miss the largest mosaic in France or the grand pipe organ, which you might be lucky enough to hear playing during your visit. As a popular attraction for tourists, pickpockets and other pesky folks are present outside the church, so be prepared to refuse pushy salespeople if they try to force their merchandise on you. No bathrooms are available within Sacré-Cœur, so plan your visit accordingly.

18th arrondissement
35 rue du Chevalier de la Barre

www.sacre-coeur-montmartre.com

Ⓜ❷ Anvers Ⓜ⓬ Abbesses

PLACE DU TERTRE

MONTMARTRE SQUARE

18th arrondissement

www.montmartre-guide.com

 Anvers
Ⓜ⑫ Abbesses

Just a stone's throw away from Sacré-Cœur, you'll delight in discovering Place du Tertre in the heart of Montmartre. Quaint and picturesque, with that perfect Parisian essence, this area certainly caters to tourists; but this doesn't make it any less enjoyable for you and yours.

Strolling through the brick-paved square lined with shops and eateries, you'll fancy yourself an artist, or at least a muse, as you wander among the dedicated painters and portraitists who spend their days soaking up inspiration in the shade of the Sacred Heart.

If you can convince your whole group to sit still for a spell, you might want to commission your own family masterpiece to hang above the mantle. Otherwise, casually peruse each creator's collection and pick up a landscape, portrait, or Eiffel Tower interpretation to carry home instead.

The area's efforts to appeal to tourists may be to your advantage if you're on the hunt for souvenirs. In addition to the lovely prints and paintings in the square, you'll find shops with every trinket and miniature landmark your heart secretly desires.

Stop in at the Espace Dalí museum to experience the surrealism of Salvador Dalí's unique mind, including a collection of more than three hundred paintings, sculptures, and engravings. Admission is a bit pricey (children under eight visit for free), but the vibrant and mind-bending pieces may appeal to kids and adults alike.

You might need refueling if you've climbed the Sacré-Cœur Dome or sat for a classic caricature, in which case it's time to find a spot at an outdoor café. With any luck, a (talented) local musician nearby will serenade your meal as you relax with a bit of lunch— and, for dessert: a huge helping of people watching.

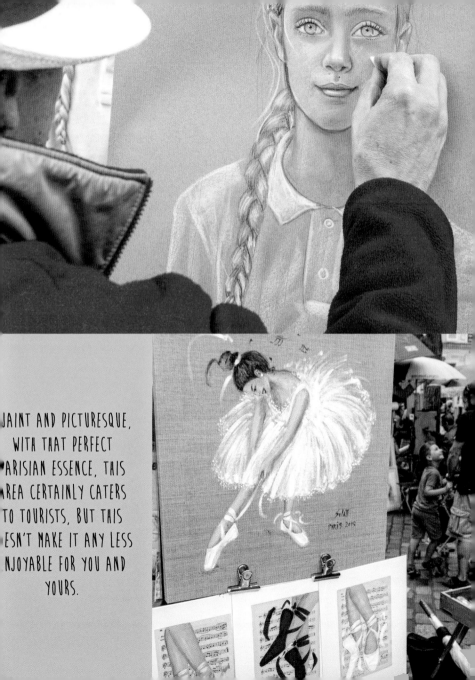

QUAINT AND PICTURESQUE,
WITH THAT PERFECT
PARISIAN ESSENCE, THIS
AREA CERTAINLY CATERS
TO TOURISTS, BUT THIS
DOESN'T MAKE IT ANY LESS
ENJOYABLE FOR YOU AND
YOURS.

CONCORDE
CHAMPS-ÉLYSÉES
BOIS DE BOULOGNE

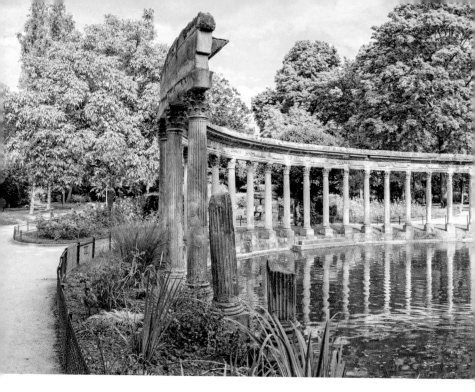

PARC MONCEAU
MONCEAU PARK

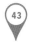

43

8th arrondissement
35 boulevard de Courcelles

www.parisinfo.com

Ⓜ❷ Monceau

CONCORDE, CHAMPS-ÉLYSÉES,
BOIS DE BOULOGNE

Pray for perfect weather, and if your wish comes true, get thee and thy family to this beautiful park. Situated on twenty acres, this precise place of leisure dates back to the 1700s, and it still includes evidence of its early origins: A large rotunda (1784) is situated at the main entrance, and a miniature stone pyramid (1778) resides within the park. A Corinthian colonnade still remains as part of the designer's original offerings, curving around a picturesque pond. A trip to the merry-go-round is most likely mandatory for the dreamers in your group—choose a classic white stallion or bright blue submarine for your journey round and round. And clearly no day in the

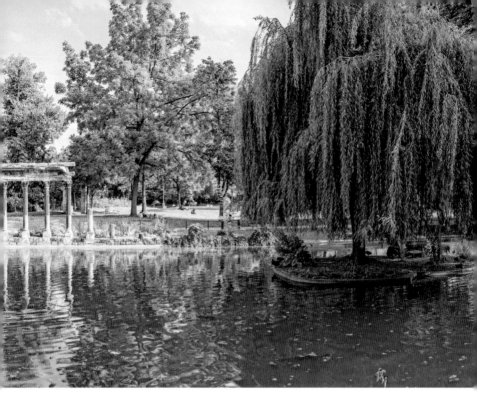

park is complete without a frolic through one or more of the popular playgrounds. Let the kids loose to climb and slide, and take advantage of the children's restrooms with pint-size facilities.

If you're lucky, you may even find a puppet show or other pop-up event to delight the kiddos. But a trip inside the grandiose gates of Parc Monceau is sure to please whether you're playing a family game of Frisbee or lazily reading in the grass. You can even break your holiday ban on technology and sneak a peek at your device with the park's free Wi-Fi.

PALAIS DE LA DÉCOUVERTE
PALACE OF DISCOVERY

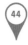

8th arrondissement
avenue Franklin Delano
Roosevelt

www.palais-decouverte.fr

Ⓜ①⑬ Champs-Élysées -
Clemenceau

Dive into discovery at this museum celebrating science in all its disciplines. Located in the west wing of the Grand Palais, on the Champs-Élysées, this magnificent collection features a multitude of permanent and temporary exhibitions to fascinate every particular personality in your ragtag group. If the vast universe and sprawling skies are of anyone's interest, take a trip to Astronomy and Astrophysics. Explore the Magic Planet, check out a Martian rover replica, or get up close and personal with an authentic lunar rock. For an extra dose of space exploration, consider paying a small fee to peek inside the Planetarium for a forty-five-minute show.

For the tiny chemist in your care, you can team up to attempt a little experiment or test your sense of smell while you analyze aromas. If you have a mathematician in your midst, head straight toward the Pi room to check out the digits displayed on the walls—or study a new side of symmetry with a hands-on approach.

Most recent in the museum's offerings of temporary exhibits, the Age of Dinosaurs takes visitors on a trip to the time of Jurassic giants and Cretaceous creatures with factoids, fossils, and a few animatronic species. But before you venture through space and time, in one wing of the museum or another, beware of the possible language barrier. About ninety percent of the exhibitions (including the Planetarium presentation) are only in French, but it shouldn't hinder your overall enjoyment of the activities. Take advantage of interactive aspects, and make each challenge your own, whether or not you're exactly certain about every detail of the instructions.

Expect to queue outdoors (in rain or shine) for admission, and if precipitation persists outside, get fully dry before encountering static in the popular electricity demonstration!

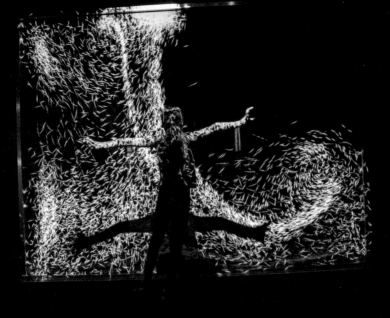

FOR THE TINY CHEMIST IN YOUR CARE, YOU CAN TEAM UP TO ATTEMPT A LITTLE EXPERIMENT OR TEST YOUR SENSE OF SMELL WHILE YOU ANALYZE AROMAS.

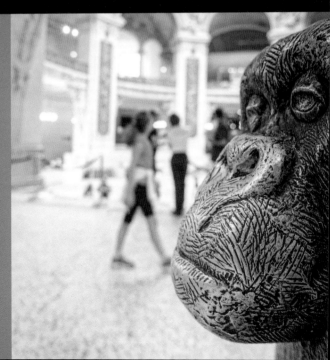

AVENUE DES CHAMPS-ÉLYSÉES

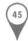

45

8th arrondissement

www.champselysees-paris.com

Ⓜ①⑨ Franklin D. Roosevelt
Ⓜ① George V
Ⓜ①❷⑥ Charles de Gaulle Étoile
ⓇⒺⓇⒶ Charles de Gaulle Étoile

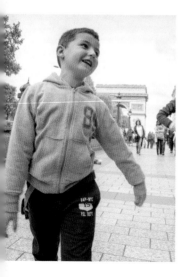

Nowhere to be, and not a care in the world? Then strolling along the Champs-Élysées is right where you belong—hand in hand with your very own brood. As you begin at the base of the Luxor Obelisk and casually wander your way toward the Arc de Triomphe, you'll happen upon a multitude of Parisian delights in a stretch just more than a mile long. Maybe you're staying in a hotel along the route, and you can simply step outside your accommodations to explore the avenue's offerings. Or perhaps your visit falls around July 14, just in time to join the throngs of French folks watching the Bastille Day Military Parade make its way down the middle of the street. But even an average (any) day of the week can take a turn toward the memorable as you look down this lane toward the superb shopping, fine French dining, and endless entertainment.

For the kiddos in your caravan, be on the lookout for a few special spots: stop in at the Disney Store to look for fellow Frenchmen like Gaston or Lumière; or peek into Petit Bateau to outfit tiny tykes in the most darling of apparel.

A host of cuisine is available from every corner of the world, along with plenty of chances to purchase clothing, jewelry, gifts, and souvenirs from the heart of Paris. Librairie Biret has your postcards, t-shirts, handbags, and hats to prove you paraded through the city of lights.

Of course you won't want to miss Les Marionettes des Champs-Élysées just down avenue Matignon. This little theater in the park features a classic puppet show that'll make your kids as pleased as Punch (and Judy). Whether you make it the full mile, stop in for a matinée movie at the cinema, or wind up picnicking at the park and playground, none of your brigade will be bored with the smattering of selections along the widespread way.

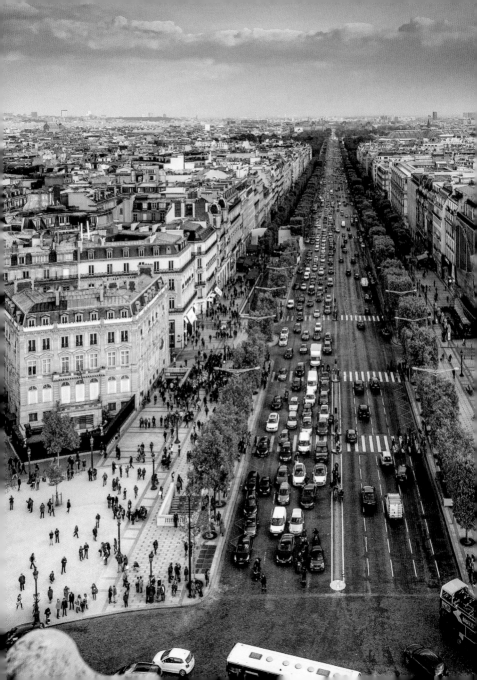

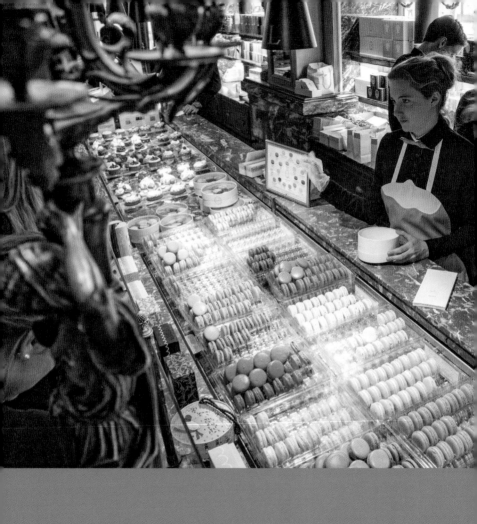

LADURÉE
BAKERY

🍴 46 🍴

Searching for the perfect Parisian macaron? The one to make you forget all the stale, strange, and stodgy sweets you've had before? Then look no farther than the legend that is Ladurée. With more than 150 years of pastry-perfecting experience, the bakers and brains at this iconic French shop know exactly how to please the palate.

Choose from a variety of appealing flavors, including coffee, citron lemon, and salted caramel—or box up one of each to take on your way. Otherwise you can always take your chances with a nondescript seasonal flavor—like the mysterious Marie-Antoinette.

This location—one of many worldwide—along the Champs-Élysées (page 104), features the added bonus of a café and tea room in which to sit and sigh at the small size of your appetite when there are so many savory and sweet selections from which to choose. Snack on a croque-monsieur, a bite of French toast, or even a trio of sliders while you sip on a (virgin) berry cocktail. Of course dessert should be fairly obvious, but there's no reason you can't pick up another pastry (why not a raspberry tart?) or a scoop of chestnut ice cream to round out your inevitable sugar coma.

You can't miss this lovely locale with its beautiful facade of green-and-gold accents; and the bar's decor has something a little special as well, though its gossamer detailing is easier to appreciate than describe. Get the family's foot in the door with the promise of masterful macarons, and stay for a magnificent meal in an enchanting atmosphere.

8th arrondissement
75 avenue des Champs-Élysées

www.laduree.com

Ⓜ①⑨ Franklin D. Roosvelt
Ⓜ① George V

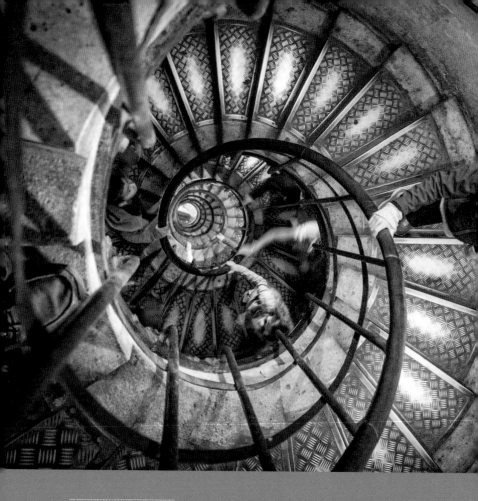

ARC DE TRIOMPHE
TRIUMPHAL ARCH

47

As you approach the Arc de Triomphe from the Champs-Élysées, its presence looms larger and grander until you are at the base of the impressive arch. As one of Paris's most iconic landmarks, this monument to France's military victories does not disappoint.

Begun in 1806 on Napoleon Bonaparte's orders, and completed in 1836 (after his death), it has since been the site of other memorable moments in the country's history, including a parade through the center at the end of World War I.

No need to dash across the heavily populated traffic junction in order to admire the edifice up close: instead take the stairs down to the pedestrian tunnel to safely reach the center of the Étoile with all children intact. Once you're back above ground, examine all 360 degrees of the ornate decor depicting battle scenes and the like in world-famous bas-relief sculptures.

Take a moment to honor the tomb of the Unknown Soldier at the eternal flame (rekindled daily at 6:30 p.m.), before venturing within to explore the recently renovated museum and interior. Children are admitted for free (adults cost twelve euros) to ascend 284 steps—or take the elevator shortcut.

The kids will enjoy engaging with interactive displays and climbing up to the tippy top to gaze in awe out from the arch's eye view. One of the best panoramas in the city, whether day or night, perhaps your youngsters can pick out a few places you've been from their rooftop perch (look for the Louvre!). Otherwise they'll be mesmerized by the dizzying traffic whizzing round below.

8th arrondissement
place Charles de Gaulle

www.paris-arc-de-triomphe.fr

Ⓜ❶❷❻ Charles de Gaulle - Étoile
ⓇⒺⓇⒶ Charles de Gaulle - Étoile

JARDIN D'ACCLIMATATION
AMUSEMENT PARK

16th arrondissement
Bois de Boulogne

jardindacclimatation.fr

Ⓜ① Les Sablons

It may be the second largest park in Paris, but at twice the size of New York's Central Park, the Bois de Boulogne has no shortage of grand greenery and appealing attractions.

Whether you're lying lazily by a lake, exploring the exotic blossoms of the botanical gardens, or simply walking beneath the shady trees, you'll find a lush landscape for outdoorsy enjoyment. Perhaps you prefer to cheer on a horse at the Hippodrome, take a boat for a lap on the Lac Inférieur, or even sneak a peek at the home of the famous French Open: the Roland Garros tennis courts.

Still it wouldn't be a fair family trip without heading to the park's main attraction—at least in the eyes of your youthful contingent—the Jardin d'Accclimation. Located in the northern portion of Bois de Boulogne, you will find the perfect destination to delight your darling children.

A crossover attraction that combines their love of animals, games, and endless amusement, all set among French foliage, this park within a park has ample opportunity to entertain the entire brood.

You can start with a trip on the tiny train from the Porte Maillot park entrance—just a short ride to amp up your excitement for all the area has to offer. And there is quite a bit to see! Take advantage of your early-day energy with a crash course in bumper cars, a speedy spin on the go-karts, and the chance to take a flying leap at the free jump. Hitch a ride on a magic carpet, or let your feet dangle as you swing high above the ground. Try not to shriek when you see your distorted self staring back at you in the fun-house mirrors, and take your best aim with a turn at the arcade games.

For a little break between high-adventure activities, take a soothing sail on the Enchanted River with

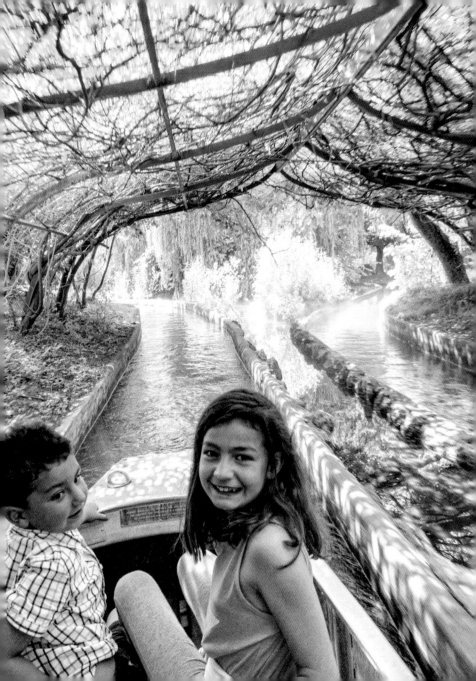

a canal ride, followed by a stop inside Le Théâtre
du Guignol for a meeting with some mesmerizing
marionettes.

Continuing on your journey will bring you face to
face with some furry friends of the animal kingdom.
Perhaps your teensiest tykes will want to promenade
on the back of a pony, dare to hitch up to a donkey,
or galumph along on the humped back of a curious-
looking camel.

Down at the farm, look out for cows, sheep, bunnies
and more—all eyeing you suspiciously, hoping for a
handful of grub.

In Le Rucher Pédagogique, a persistent sound of
buzzing is nothing to alarm—just more than 200,000
bees hard at work making delicious honey. Watch your
head in the Great Aviary, where more than 200 birds
rule the roost. Spotting parrots, macaws, and doves
can be a flight of fancy as long as nothing unpleasant
should fall from the sky.

And over at Le Rocher aux Daims, a gaggle of goats
and a family of deer won't mind if you stop by to say
hello. Tell the kids to pick out the fawns that most
resemble their own personalities—is it the one with
the funny face? Or the darling doe nibbling on a
scrumptious snack?

Speaking of snacks, don't forget to dine during your
busy day. You can find food and drinks to fill up the
family at a few spots around the park, including Le
Petit Pavillon for sandwiches and salads, La Terrasse
du Jardin for hearty cuisine, and La Crêperie de la
Petite Ferme for—you guessed it—delicious sweet and
savory crêpes.

Don't wander away without a hike on the wooden
walkways of Forest Adventures. A series of ladders,
bridges, and platforms create this kid-sized kingdom
for your youngsters to run and rule. Once they've

mastered one domain, test your family's flexibility on the ropes-reliant obstacle course. Or get the whole gang to join in for a daring dash down the Tyrolienne zip line, soaring over the park and spotting the next stop on your journey.

Guide the group to a change of pace for the small sailors amongst you. Kids can pick out a pint-sized craft—perhaps a fireboat or coast guard's ship—and steer the lot of you on a smooth skip around Les Canots du Lac.

Soak up some culture with a look around La Maision de Kiso (an authentic Japanese house) and Le Jardin de Séoul (the Garden of Seoul) before calling it a day. Of course if the offerings inside Jardin d'Acclimatation somehow lack enough allure for older kids in your brigade, you can still find some fun within Bois de Boulogne. Perhaps a round of mini golf will please any tweens and teens who have outgrown other follies.

As happy and pleasant as you'll find the park during daylight, it's best to head out before dark, as a different type of crowd inhabits the premises at night.

FONDATION LOUIS VUITTON

LOUIS VUITTON FOUNDATION

16th arrondissement
Bois de Boulogne
8 avenue du Mahatma Gandhi

www.fondationlouisvuitton.fr

Ⓜ① Les Sablons

Within Bois de Boulogne's park within a park, Jardin d'Acclimatation, you'll find the architectural wonder that is the Fondation Louis Vuitton. Designed by Frank Gehry (world-renowned for structures like the Walt Disney Concert Hall in Los Angeles), this stunning edifice won't fail to peak the whole family's curiosity with its breathtaking glass shells overlapping like waves on the shore.

Known as the "cloud of glass," the building is certainly a sight to behold, there among the lush greenery of the surrounding park.

This young museum and cultural center, open only since October 2014, holds a vast number of artworks owned by luxury brand LVMH and its CEO, Bernard Arnault. Within its walls, you can view themed exhibitions from visiting pieces as well as the permanent collection, including artists like Jean-Michel Basquiat, Piet Mondrian, and Henri Matisse. The foundation even offers short family tours to make your little ones feel included, or you can head to a children's workshop for some hands-on fun.

Perhaps the simplest way to persuade your picky offspring of a trip inside is merely to mention the museum's handy iPads. Complete with an animated tour guide to talk to your kids, the tablet's Apprentice Architect app gives young visitors the chance to explore and enjoy their surroundings in a fun and clever way.

Or if musical entertainment is more to your liking, you may be able to enjoy a recital or concert from any number of visiting performers in the center's auditorium.

The Foundation's online calendar makes planning easy in order to peruse what offerings might most please your youngsters. Still, if none of the exhibits are to your liking, a quick look around the bookshop or a bite to eat in the restaurant won't cost you a ticket.

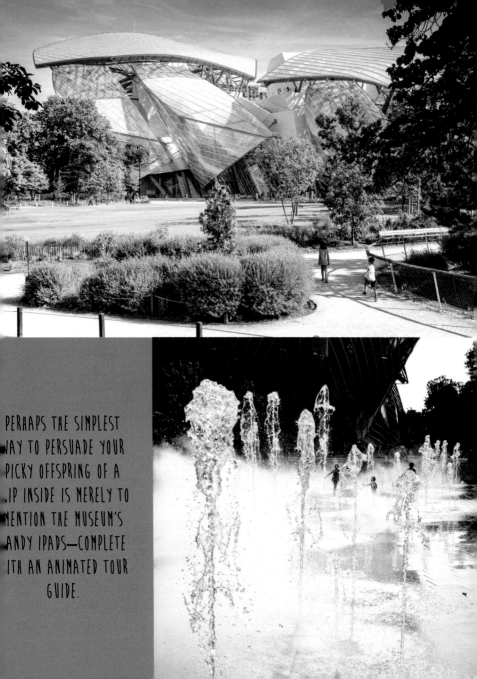

PERHAPS THE SIMPLEST
WAY TO PERSUADE YOUR
PICKY OFFSPRING OF A
TRIP INSIDE IS MERELY TO
MENTION THE MUSEUM'S
HANDY IPADS—COMPLETE
WITH AN ANIMATED TOUR
GUIDE.

123 CISEAUX
HAIR SALON

17th arrondissement
10 boulevard de Courcelles

www.123ciseaux.com

Ⓜ❷❸ Villiers

If the kids are starting to look a little shaggy on your time away from home, they might not mind sitting for a trim at this particular hairdresser.

With its vibrant and vivacious decor, purple mirror stations, and playful atmosphere, your youngsters can be cheerful and relaxed as soon as you arrive. They may have the chance to sit on a stool shaped like a motorcycle, or perhaps on the back of a swift white horse. Or maybe they'll just be snuggled up in a pint-sized armchair while their locks are lightened.

But it isn't just the seating and bright surroundings that will appeal to your offspring. Rather the video consoles situated at each styling station that play cartoons will ensure the happiness of your little heroes and heroines for the duration of the haircut. Rest assured, any children waiting patiently are not to be ignored. The fun and funky living room features a selection of books, toys, and video games to keep all members of the squad easily entertained.

A small smattering of clothes are also for sale in case you're looking to pick out a Parisian outfit or swap out a shirt after your kid's cut.

The costs of services are a bit on the pricey side, ranging from twenty to twenty-five euros, depending on age of the child, but the calm convenience might just make it worth it. And as an added bonus, every kiddo leaves 123 Ciseaux with a small gift of his or her choice, a little souvenir of an unforgettable visit.

Brandt

TROCADÉRO
TOUR EIFFEL
INVALIDES

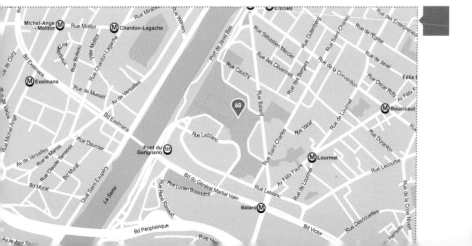

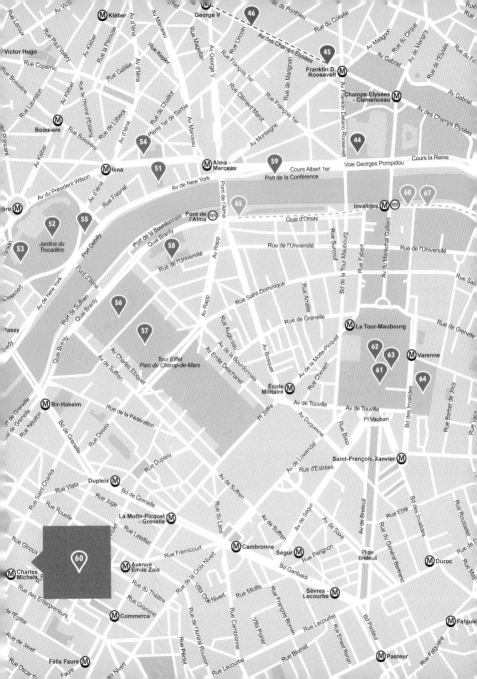

PALAIS DE TOKYO

MODERN ART MUSEUM

16th arrondissement
13 avenue du Président Wilson

www.palaisdetokyo.com

Ⓜ Iéna
Ⓡ Pont de l'Alma

When you're ready to step away from the medieval masterpieces of many of the museums around Paris, you can find an ample collection of modern art at the Palais de Tokyo.

Housed within a sprawling structure decorated with bas-relief sculptures, the building has received renovations in recent years, opening it up to more space and more natural light to complement its internal construction of columns and concrete. At more than 200,000 square feet, it now boasts the honor of largest contemporary art museum in Europe. What you'll find within is a rotating selection of temporary exhibitions, whether it be a collection of abstract paintings, a multimedia montage celebrating modernity, or an intricate and imposing sculpture made from a thousand wooden slats. A past installation even presented visitors with the chance to float along dreamily in a gondola, so the possibilities for upcoming exhibits are endless.

If you're wondering what's in store exactly for your scheduled visit, a trip to the Palais de Tokyo website might be worth the time. You can expect a certain level of interactivity interspersed throughout, which instantly makes this experience more appealing for the child who likes to touch everything.

Not one to leave out young art admirers, the museum's Tok-Tok Program celebrates the interests of your kiddos with a slew of activities in an array of age ranges, so you'll want to consider booking participation online. Admission is free for anyone under eighteen years old.

When the family starts to interpret every abstract piece as various plates of food, it's time to seek out a snack. Situated along the bank of the Seine, the center's Monsieur Bleu restaurant offers views of the river and Eiffel Tower, or you can grab a table at Tokyo Eat for a bite of lunch in the airy atmosphere.

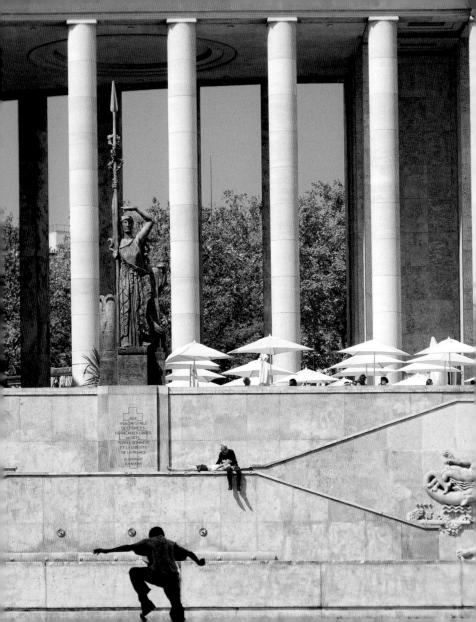

PLACE DU TROCADÉRO

TROCADÉRO SQUARE

52

16th arrondissement

www.parisinfo.com

Ⓜ︎Ⓒ︎◯ Trocadéro

For the best view of the city's main event—none other than the Eiffel Tower itself—you'll want to take some time within the curved wings of the Palais de Chaillot on the Place du Trocadéro. This sprawling space in between the identical colonnades of the palace and the tower itself—which sits just across the Seine—will be your best bet for an impromptu portrait session of the kids posing in front of the iconic landmark. Whether you're there during the day for a spot of sunshine, or visiting at night to see the stunning sparkles of the tower's twinkle lights, you'll capture the image of your imagination with this truly breathtaking sight.

Continue your exploration of this spacious spot with a stroll through the Jardins du Trocadéro. The lush, green landscape, free and open to the public, features large expanses of shady trees off to each side of the area's main attraction: the Fontaine de Varsovie. This enormous and impressive collection of fountains stretches the length of the park, and features an impressive forty-six water spouts and twenty water cannons, which can shoot water a distance of fifty-five yards. Especially enticing in the warm summer months, your offspring may not be able to resist dunking their toes in the cool fountain water. Evenings in summer may add an additional allure to the sights as multi-colored projections decorate the dancing spray. But even just the picture of the waving water in the foreground of France's legendary landmark is certainly a sight to see—if you can get everyone to stand still for a moment to take it all in. Reward your youngsters for their picture-taking patience with a spin on the park's large and ornately decorated carousel. Of course, if the weather doesn't cooperate, you can always head underground to L'Aquarium de Paris (page 128) nearby to visit the sharks and sea creatures.

TROCADÉRO, TOUR EIFFEL, INVALIDES

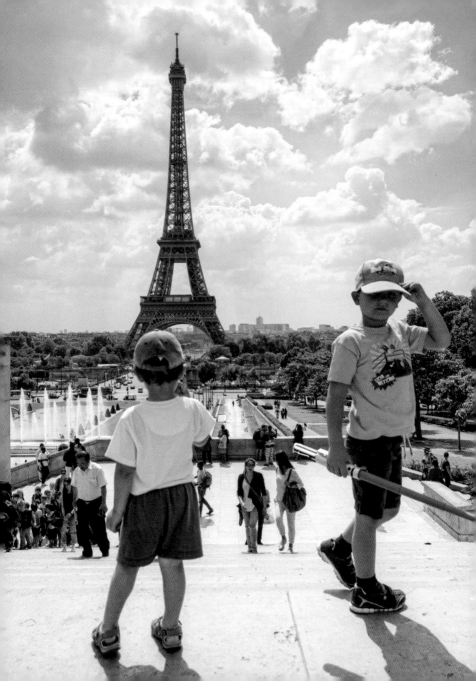

MUSÉE DE L'HOMME
PALAIS DE CHAILLOT
THE MUSEM OF MAN

16th arrondissement
17 place du Trocadéro
et du 11 Novembre

www.museedelhomme.fr

Ⓜ❻❾ Trocadéro

Housed within the western wing of the Palais de Chaillot, just across the Seine from the Eiffel Tower, the Musée de l'Homme—the Museum of Man—celebrates the anthropology and fascinating origins of the human race.

Recently renovated and reopened in the fall of 2015, it now proudly contains one of the most comprehensive prehistoric collections worldwide.

With plenty of skeletons and anatomical representations on display, some items might be a bit scary for younger kids; then again, it is often the gross and creepy that appeals to the twisted minds of our offspring. If this is the case for your kin, the sculpture of the innards of a dead elephant laid out grotesquely will be right up their alley.

Largely labeled in French, it's a bit difficult for English speakers to get the full picture of every exhibit. Still, appreciating the artistry of tribal masks, the evolution of prosthetics, or the eerie magnificence of a real mummy won't require a mastery of the local language. Don't miss the opportunity for your youngsters to listen in on a bit of music from across the world, or a recording of languages you never knew existed at the tactile wall of tongues.

Take advantage of various videos and interactive items around the museum, and look for the increasing number of displays including English and Spanish language options as improvements are made.

Be sure to visit the museum's clean bathrooms, and consider picking up a snack in the Café de l'Homme or Café Lucy before heading out to enjoy a picnic in the Jardins du Trocadéro. With its location just across the way from the Eiffel Tower, here you'll continue adding to your list of perfect places from which to spot the iconic landmark.

MUSÉE DE LA MODE DE LA VILLE DE PARIS

PALAIS GALLIERA

CITY OF PARIS FASHION MUSEUM (GALLIERA PALACE)

16th arrondissement
10 avenue Pierre 1er de Serbie

palaisgalliera.paris.fr

Ⓜ️ Iéna or Alma Marceau

Despite its varied and tumultuous beginnings from the late 1800s to the mid-1970s, this modest-sized museum has since seen success as a space for a rotation of temporary fashion exhibitions. Open only when these short-term shows are taking place, you'll want to check the website before making the trek to be sure there's something to see—and that it appeals to all of your entourage.

That being said, every exhibition has something new and chic to flaunt—from history to haute couture, every era and every trend known to woman and man. One such past offering, Anatomy of a Collection, was an interesting introspection into the (un)official uniforms worn by all manner of people from blue collar to blue blood in the past three centuries. Marie Antoinette's corset, a World War I nurse's garments, and a sample of Audrey Hepburn's stunning styles were among the looks on parade.

Perhaps you have a fashionista in your family who will appreciate every dramatically displayed stitch and seam of the intricate and significant clothing pieces and antique accessories—some true works of art in their own right.

Housed inside a building as beautifully dressed as the models within, your family will appreciate the beaux-arts architecture as you are dazzled by Parisian apparel. Don't forget to take the chance to tootle around the grounds and gardens before you jet off to buy your own French fashions (after so much inspiration inside).

Admission is free for anyone under eighteen, and the museum is closed on Mondays (as well as in between exhibitions). Guided tours are offered throughout the week without reservation required, so check the website or inquire upon arrival for times and English availability. Note: Photography may not be allowed during select exhibitions.

L'AQUARIUM DE PARIS

16th arrondissement
5 avenue Albert de Mun

www.cineaqua.com

 Trocadéro
Iéna

There's nothing fishy about taking time during your travels for an activity that caters largely toward the littlest members of your group. L'Aquarium de Paris offers oceans of family-friendly fun with its array of amphibians, its silly shows, and its marine-themed movies.

Travel through a tunnel of sharks, crawl toward the crustaceans, jump by the jellyfish, or make your mark in a crafty workshop for the kids.

Your main event will be the touch tank where your youngsters can get a feel for the smooth slipperiness of brightly colored creatures, like koi and other carp. And don't miss the interactive stream projection, where tiny tykes can splash and scare their finned friends without getting soaked themselves.

Of course you might as well take the chance to meet a mermaid, check out a triton, or hang with a gaggle of goofy mascots while you're on the premises.

A few films are offered in two theaters throughout the day, but be aware of language limitations. Ask an attendant whether it's worth it for English speakers before getting your group situated in their seats.

Admission tickets for L'Aquarium de Paris are a tad pricey (ranging from thirteen euros for kids twelve and under to twenty euros for adults), but taking the time to explore every inch of this smallish spot may make it worth your money.

Consider grabbing a bite to eat at Zen Café before you go; you might need the energy if tackling the stairs of the Eiffel Tower is next on your list.

LA TOUR EIFFEL

EIFFEL TOWER

56

7th arrondissement
Champ de Mars
5 avenue Anatole France

www.toureiffel.paris

Ⓜ⑥ Bir-Hakeim
Ⓜ⑨ Trocadéro
®ⓔ© Champs de Mars - Tour Eiffel

Synonymous with Paris itself, the Eiffel Tower is the city's crowning achievement. Whether it's shining in the sunlight, hiding beneath layers of French fog, or twinkling like a million flashbulbs in the night sky, this iconic landmark has an undeniable presence in the city of lights. Of course you'll want to climb on the clearest day possible, in order to take advantage of the best views for miles around.

Whether you've been waiting to wind your way up, or dreading the crowds of tourists much like yourself, you can't escape the allure of a visit to this top attraction. Originally built as a temporary exhibit for the 1889 World Fair, Gustave Eiffel's edifice instead earned a permanent place with its popularity (and practical ability as an antenna platform). It stood as the world's tallest structure for four decades, and is still a sight to behold in the Parisian skyline. Save little legs by taking the lifts, and save yourself some time by purchasing your elevator tickets online in advance. You can even buy them on your smart phone to be scanned at the entrance. Take note of the time you chose on your ticket, and don't be more than a few minutes late to gain admittance without enduring long lines.

If, instead, you're one of those fit families determined to use the stairs, you can buy your tickets at the base of the tower, taking your time as you climb to enjoy a specific view that others may miss. Stairs aren't available to the third floor, but you can buy a supplement ticket to ride the rest of the way (or even from floor one if you tire out quickly).

If everyone is impatient for the faraway views immediately upon arrival, ride to the second floor and switch lifts to head up to the tippy top—be sure to bring a jacket for breezy conditions. Take advantage of the telescopes to spy on unsuspecting folks down

below and spot sights you've already seen around town. Peek in on Gustave Eiffel's office recreation, frozen in time during an important meeting of minds. Then, once you've had your fill of gazing and gawking at the city all around you, make sure to stop back by the second and first floors for engaging exhibits and a glass-floor glance down at the ground beneath.

You can pick up your obligatory souvenirs at the gift shops on floor two, or grab a snack and a coffee down below.

If you're in no rush, you can take the time to dine at almost 200 feet in the air in the first floor pavilion or almost 400 feet up on the second floor. Both are a bit pricey (costs are twice as high when you're twice as high), so check the menus online before your visit, and decide whether to make a reservation.

Nowadays there's an app for everything, so your kiddos can check out the English version of the official Eiffel Tower app, complete with audio guide and panoramic views. Or checking out the website ahead of time will introduce you to Gus, who can give youngsters their own tour with an interactive booklet. No need to fret about full bladders while enjoying your visit; toilets are available at the base of the east and west pillars, as well as the second and top floors.

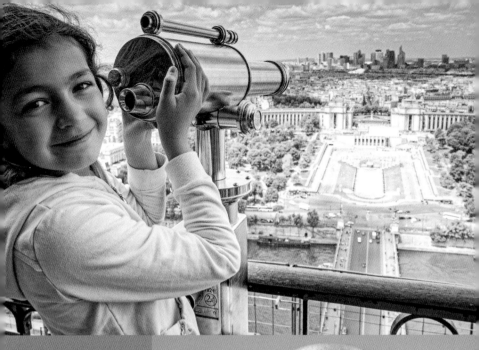

WHETHER IT'S SHINING IN
THE SUNLIGHT, HIDING
BENEATH FRENCH FOG,
OR TWINKLING LIKE A
BILLION FLASHBULBS IN
THE NIGHT SKY, THIS
ICONIC LANDMARK HAS AN
UNDENIABLE PRESENCE IN
THE CITY OF LIGHTS.

CHAMP DE MARS
PUBLIC PARK

57

7th arrondissement
2 allée Adrienne Lecouvreur

www.parisinfo.com

Ⓜ❻ Bir-Hakeim
Ⓜ❾ Trocadéro
Ⓜ❽ École Militaire
ⓇⒺⓇⒸ Champs de Mars - Tour Eiffel

Even when you're through visiting the Eiffel Tower, you'll still be admiring it from afar, and the Champ de Mars may be the perfect place to pose your picturesque family for photographic evidence of your affection for the iconic landmark.

Originally used as a parade ground for eighteenth-century cadets, this sprawling space of grass and greenery now serves as a popular park for picnicking and other pleasant pursuits.

Enjoy the wide open expanse to admire a (hopefully) bright blue sky, and nap in the summer sun. When the feet of your frenzied offspring start to get itchy, you can venture on to one of three playgrounds throughout the park. For your tiniest tykes, the smallish option in the southeast corner might be the least intimidating.

Whatever you choose, your youngsters can expel extra energy on the climbing structures, slides, and sandboxes before you meander as a group to the park's ornate carousel. Nearby you'll find a café for coffee or snacks; and pony rides or puppet shows might be on the menu for the day if the weather cooperates.

Look for the duck pond to visit fine feathered friends, or head to the gazebo to check for musical performances. Even if nothing of note is scheduled for your stop, your kids will appreciate the spacious area to run and play without the restrictions and rules of stuffy museums.

Do not be alarmed by aggressive salespeople pushing their wares within the park. If you are not interested, a firm "No thank you" should send them on their way.

Should you have any extra oomph in your step (or the desire to hail a cab), you can travel just less than a mile away to say hello to the Statue of Liberty. A thirty-five foot replica of France's famed gift to the US sits on a tiny island in the Seine, which you can access from the Pont de Grenelle bridge.

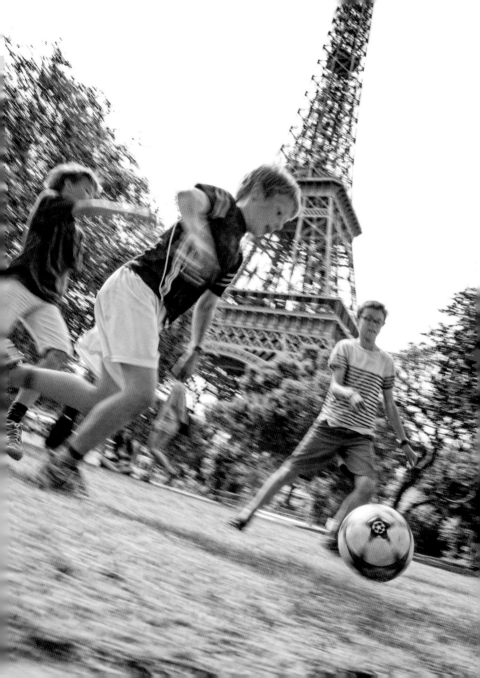

MUSÉE DU QUAI BRANLY
HISTORY MUSEUM

58

7th arrondissement
37 quai Branly

www.quaibranly.fr

Ⓜ️⑥ Bir-Hakeim
Ⓜ️⑧ École Militaire
Ⓡ️Ⓔ️Ⓡ️Ⓒ Pont de l'Alma

Just up the Seine from the Eiffel Tower, you'll know when you've arrived at the Musée du Quai Branly by its odd and colorful exterior—a collection of mismatched blocks in reds and oranges protrude from the building.

Within its walls you'll find a celebration of indigenous peoples, artifacts, and artworks from Oceania, the Near East, Asia, Africa, and the Americas. Discover an innovative intricacy in the careful craftsmanship of creations ranging from 10,000 BC to the twentieth century.

Whether you're intrigued by the inventive tools we take for granted, or amazed by the grand garb, the amount of genuine history to soak up is overwhelming in only the best way.

Encourage the kiddos to take a look at the tribal masks of each culture, and study the sculptures, considering the artist's source of inspiration. Enjoy stunning displays, informative videos, and an impressive atmosphere as you make your way through this elegant museum.

Your best bet for a successful visit is to take advantage (for a small fee) of the English-language audio guide in order to learn more about the exhibits you're viewing, with tours geared to both children and adults. You can also request an Adventure Passport for your youngsters at reception to receive a free gift, or download the museum's free app, available in French or English, to further enhance your exploration.

Looking for an al fresco meal with a stunning view of an iconic landmark? Search no farther than the Café Branly in a charming garden setting before venturing out to explore the equally appealing grounds.

Lastly, toilets are available, but a bit sparse throughout the museum, so be sure to stop in when you're nearby.

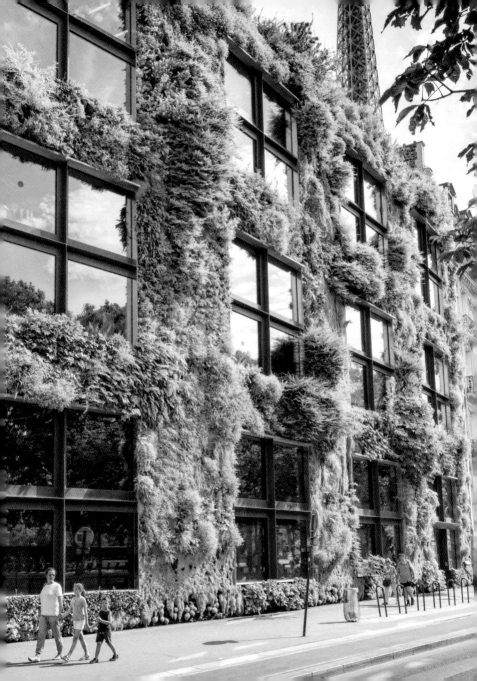

BATEAUX MOUCHES
BOAT TOURS

59

8th arrondissement
pont de l'Alma

www.bateaux-mouches.fr

Ⓜ⑨ Alma-Marceau
or Franklin Roosvelt
Ⓜ①⑬ Champs Élysées -
Clèmenceau
Ⓡ€Ⓒ Pont de l'Alma

Hitch a ride down the Seine with the river cruise company that's been tootling tourists through the city for more than sixty years. Departing from the Pont de l'Alma, you'll purchase your tickets online or at the ticket window to reserve a seat aboard one of nine, glass-enclosed boats. From one of these you will see the sights of the city of lights from a whole new perspective. Pick a spot inside if the weather is rainy, or get a breath of fresh air out on the open deck for better visibility of all the amazing architecture and prime Parisian attractions on each bank of the river.

If you're looking for a little extra from your experience, consider booking a spot on one of six dining crafts, for lunch or dinner. You can enjoy a bit of violin music or piano playing as you sample selections from one of three prix fixe menus, although reviews of the food are somewhat hit and miss.

You'll pass by some of the highlights of your holiday itinerary, during your seventy-minute tour, including Notre Dame, the thirty-five foot Statue of Liberty model, and the Louvre. Sunset cruises offer the benefit of combining a bit of daylight with the enchanting quality of the city at night, especially if you catch the Eiffel Tower in its hourly time of twinkling perfection. Commentary is rather brief, so you won't get the play-by-play of every place you pass, but it's presented in eight languages for your convenience.

Tip: Toilets on board are available, but nothing fancy; and don't forget seasick remedies for any sensitive tummies in your group in case of emergency.

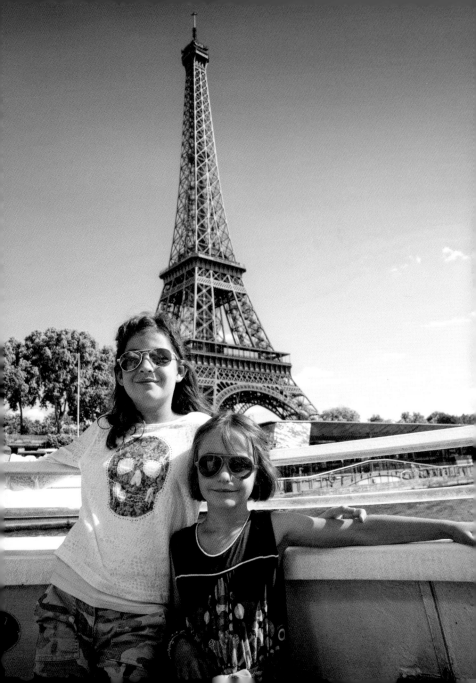

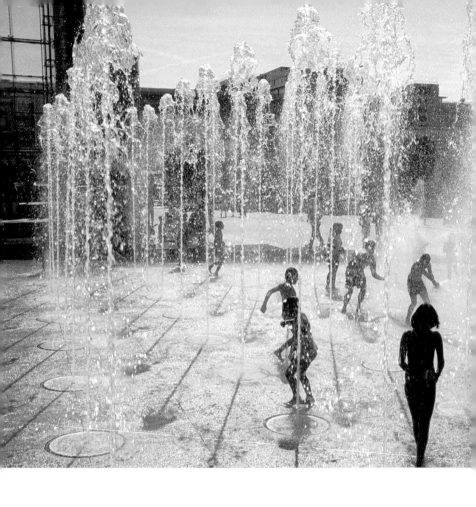

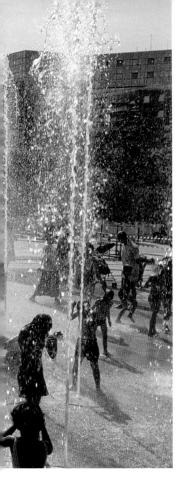

PARC ANDRÉ CITROËN

ANDRÉ CITROËN PARK

Formerly the site of the Citroën factory, this modern Parisian park has an altogether different look and feel than any other throughout the city.

First opened in 1992, the unique area almost feels like living art as you step inside to see concrete-walled gardens and glass greenhouses.

The centerpiece of this carefully planned property is the enormous hot air balloon, which can fit thirty adults and sixty children. At prices ranging from free to twelve euros (depending on age and day of the week), a trip 500 feet in the air might be worth the fee if weather cooperates.

Otherwise, the most appealing attraction for your offspring will be the flat, paved avenue where they can run and frolic through jets of water that shoot up from the ground.

However, if weather won't allow for soaked children, the large expanse of grass in the center of the park is perfect for playing Frisbee, a game of tag, or a lazy group lounge with a snack or a snooze.

Most of the gardens are named for a color, and the White Garden is where you'll find a playground, ping-pong tables, and the sandbox (which you may want to avoid with wet children).

Explore the pair of matching greenhouses (their interiors differ throughout the year), and look for the wall of waterfalls at the north end of the park—or challenge your children to pick out their favorite color-themed garden.

Take advantage of clean bathrooms on-site, as well as the drinking water station, with still or sparkling options—in case you're feeling fancy.

15th arrondissement
2 rue Cauchy

www.parisinfo.com

Ⓜ⑩ Javel - André-Citroën
Ⓜ⑧ Balard
ⒺⒸ Javel

HÔTEL NATIONAL DES INVALIDES: MUSÉE DE L'ARMÉE

NATIONAL MILITARY MUSEUM

61

7th arrondissement
129 rue de Grenelle

www.musee-armee.fr

Ⓜ⑧ La Tour - Maubourg
Ⓜ⑬ Varenne
RERⒸ Invalides

It shouldn't be much of a battle to interest your kids in a march to the Musée de l'Armée, where military history is celebrated with a series of fascinating facts and artifacts.

The sheer size of some exhibit highlights will engage your youngsters, including intricate and ornate armour from the sixteenth century, a red-and-yellow taxi cab of sorts, and the artillery collections situated in the museum's main courtyard.

Learn about the French perspective and participation in worldwide wars, and admire the antique muskets and royal riches. Travel through several centuries, and challenge your children to choose the most engaging era.

A musical instrument room with odd-looking objects might interest anyone less inclined toward military monuments, and the Charles de Gaulle tribute includes interactive and multimedia exhibits.

Pick up an iPad (six euros to rent) for the kiddos to enjoy explanations, quizzes, and an interactive map presented in English (or three other languages). Additionally, a scavenger hunt provides an extra bit of fun for youngsters to search for specific surprises throughout the collections.

Pop in for a salad or sandwich at Le Carré des Invalides, and peruse the book and gift shop if someone is itching to know more about a certain subject you stumbled upon.

Housed within the Hôtel National des Invalides, the museum shares the spacious property with other museums and memorials, as well as a hospital and home for injured and retired war veterans.

Outside, the large Esplanade des Invalides stretches to the bank of the Seine, providing plenty of room for the kids to run and play in the grassy expanse. Admission is free with the Paris Museum Pass—or for anyone under eighteen years old.

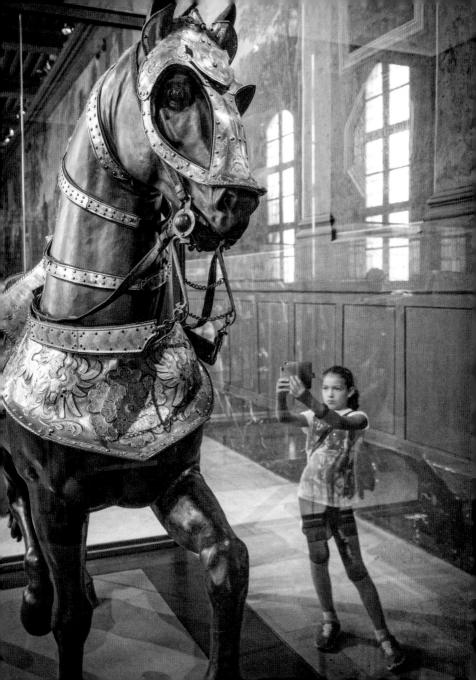

HÔTEL NATIONAL DES INVALIDES:
TOMBEAU DE NAPOLÉON
NAPOLEON'S TOMB

62

7th arrondissement
Dôme des Invalides
129 rue de Grenelle

www.musee-armee.fr

Ⓜ⑧ La Tour - Maubourg
Ⓜ⑬ Varenne
ⓇⒺⓃⒸ Invalides

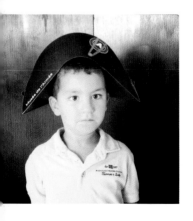

As you visit the Musée de l'Armée (page 142) within the Hôtel des Invalides, you'll also inevitably make your way to the centerpiece of the property: the Église du Dôme, or the Dome Church. From its exterior, it is the glittering gold focal point of the complex, and inside you'll stare up at the ceiling to admire the impressive work of French painter Charles de la Fosse. The Tomb of Napoleon Bonaparte itself is unique and extravagant, comprising six coffins of various colors and materials—the outermost a deep, rich red—that fit one inside the other to contain the ruler's remains. Originally buried in the shade of a willow tree, Napoleon's body was exhumed in 1840 and transported to its current location.

Twelve figures are positioned around the tomb to represent the military victories of the man of small stature. Bas-relief sculptures, the decorative marble floor, and additional statues add to the ornate nature of the room and tomb's presentation, which also includes the simple tombstone from the emperor's original grave site on Saint Helena island.

Within the room, you'll also find the tombs of the kin of Napoleon I, including his son, l'Aiglon, and his brothers Joseph and Jérôme Bonaparte. And in the alcoves of the church, other French war heroes are laid to rest.

Admission to the Dome Church is included with your entrance to the Musée de l'Armée, and you'll be glad to have your audio guide with you in this section of the complex to provide details about Napoleon and his prominent place in French history.

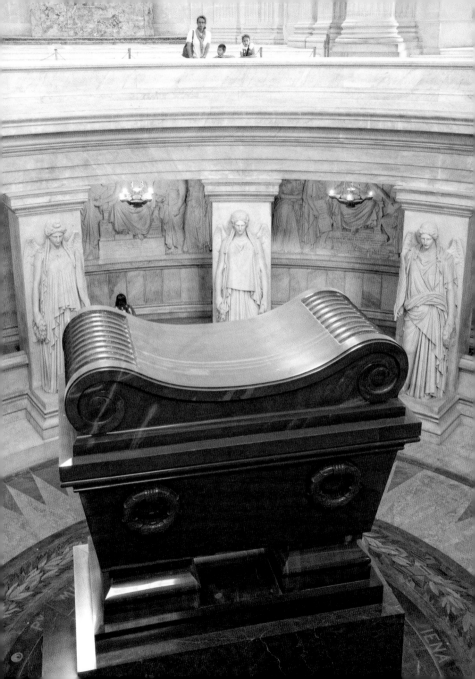

HÔTEL NATIONAL DES INVALIDES: MUSÉE DES PLANS-RELIEFS

MUSEUM OF RELIEF MAPS

63

7th arrondissement
6 boulevard des Invalides

museedesplansreliefs.culture.fr

Ⓜ⑧ La Tour - Maubourg
Ⓜ⑬ Varenne
ⓇⒸ Invalides

Take full advantage of your admission ticket to Hôtel National des Invalides with a stop in at Musée des Plans-Reliefs after you explore the antique artifacts of the Army Museum (page 142) and the eerie elegance of Napoleon's Tomb in the Dome Church (page 144). This wing of the sprawling complex celebrates amazing intricacy with its collection of military models dating back hundreds of years. These miniature representations of landmarks, fortresses, and tactical targets are truly impressive in their attention to detail and historical significance. Even in their proportional smallness to the sites they are imitating, the sheer size, up to twelve feet, of some of the representations makes them that much more interesting to examine.

Almost like fanciful dollhouses or luxurious Lego sets, it might be a bit disappointing for your youngsters that they can't touch or play with the protected properties. But considered top secret until just more than fifty years ago, these important pieces of military strategy might impress your youngsters as they have the opportunity to view such previously secretive replicas. After taking a glance at each of the structures on display, ask the kids to make their case for which model is the best masterpiece.

As one of the less populated museums in Paris (a hidden gem), you'll enjoy the extra breathing room as you have the chance to admire the monuments up close.

If your schedule for the day is a bit light, or unfortunate weather has thrown a wrench in your plans, you might check into reserving a spot for your kids in an available workshop to further their enjoyment of the intricate displays in this particular military museum.

MUSÉE RODIN
LE JARDIN DE SCULPTURES
RODIN MUSEUM
(SCULPTURE GARDEN)

64

7th arrondissement
79 rue de Varenne

www.musee-rodin.fr

 Varenne

At the Musée Rodin, it'll most likely be the distinct and dazzling sculpture garden that impresses your playful posse rather than the admittedly remarkable pieces inside. Stretching over more than seven acres, you'll have the opportunity to visit the rose garden north of the chateau, as well as the exquisite ornamental garden to the south.

Combining the peaceful pleasantness of strolling through a lush landscape with a fascinating foray into the creative mind of Rodin makes for an experience the whole family can enjoy.

With the opportunity to choose a thematic path, you may want to discover the Garden of Orpheus, or the water-filled Garden of Springs. And an optional audio guide might enhance exploration, depending on your level of interest.

You may or may not be surprised to recognize such famous pieces during your walks as *The Gates of Hell* and *The Kiss* (parents be aware of potentially racy subject matter). Don't miss *The Thinker*, which your offspring might even recognize from pop culture references like the *Night at the Museum* film sequel. Situated behind glass to keep them protected from the elements, you can also gaze at the artist's collection of marble sculptures in their dedicated gallery.

The tea room has you covered for a light lunch or snack, with soup and hot chocolate to warm you up if the gardens are chilly.

Should you decide to venture inside the lovely chateau that is the Hôtel Biron, you'll find many more masterpieces from Rodin to admire—he donated his work to the residence in order to live there in his final years. Stroll through the halls of the artist's home and studio to peruse the collection, and enjoy the light-filled space within the adjacent renovated chapel on the property.

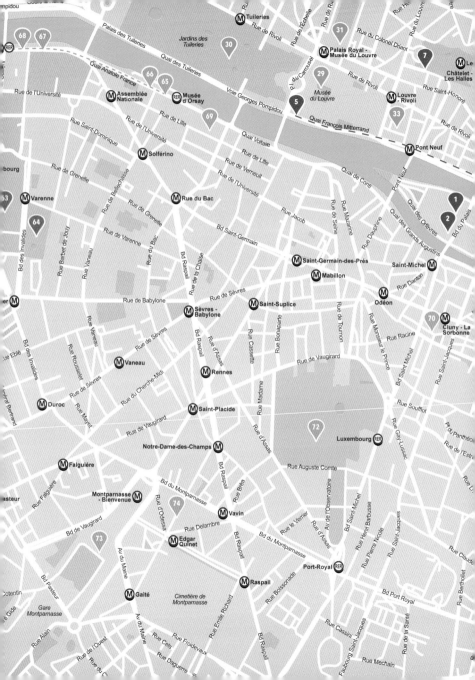

ORSAY
MONTPARNASSE
QUARTIER LATIN
LUXEMBOURG

LES BERGES DE SEINE
SEINE RIVERBANK

65

7th arrondissement
quai d'Orsay

www.parisinfo.com

Ⓜ❽⓭ Invalides
Ⓜ⓭ Varenne
🆁Ⓒ Pont de l'Alma or Invalides
or Musée d'Orsay

Stretch your limbs out on the left bank of the Seine
with a relaxing saunter around this mile-long paradise
for your kids and the kid in you.

Filled with family-fun activities to while away a sunny
afternoon, take a break from rules and restrictions to
play in this pedestrians-only area.

Your youngsters can harness their inner acrobats
while scaling a wall within safe distance of the
ground. There's a bright yellow maze to master,
and classic games to enjoy, like hopscotch and
backgammon. Make your mark on the chalkboard
wall, taking artistic inspiration from your view of
the adjacent river; or search for fossil imprints of
seashells in the walls where the Seine used to rise.
Skateboarders will surely be practicing their tricks
on the varied landscape, and runners will sprint
past on the track. Keep your ears alert for the sounds
of music, as there may be an emerging dance party
nearby to join.

Challenge the kids to a game of swingball, and check
out the floating gardens with fresh foliage stretching
up to the sky. Don't miss the five islands moored to
the riverbank with themes like mist and orchards; on
the meadows isle you'll find a row of hammocks in
which to cozy up.

If an empty lounge chair is calling your name, park a
parent within view of the promenade to keep an eye
on offspring as they explore.

Check out a board game if energy is low, or rent a
glass "Zzz" pod to curl up for a proper snooze. When
the kiddos need a little something to refuel, a slew of
takeaway restaurants, with pizza and other goodies,
will do the trick—along with a jolt of java from the
Le Faust airstream that may be parked along the way.
With plenty of space and new novelties to discover
and explore, you'll surely lose track of time as you
enjoy all Les Berges has to offer.

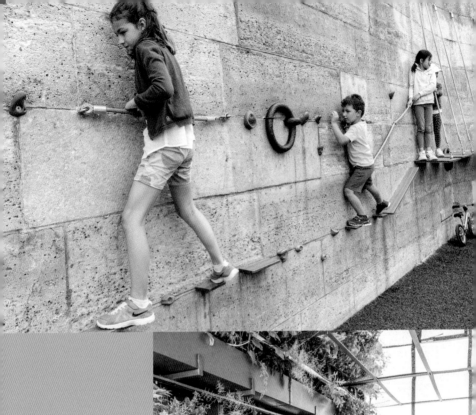

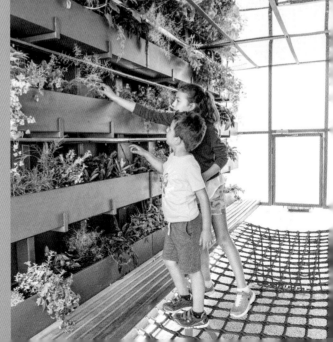

ILLED WITH FAMILY-FUN
TIVITIES TO WHILE AWAY
SUNNY AFTERNOON, TAKE
BREAK FROM RULES AND
ESTRICTIONS TO PLAY IN
THIS PEDESTRIANS-ONLY
AREA.

MOZZA & CO.
MOBILE TRATTORIA

7th arrondissement
Berges de Seine Rive Gauche
port Solférino
11 Quai Anatole France

www.mozzaandco.it

Ⓜ⑫ Solférino
ⓇⒺⓇ Ⓒ Musée d'Orsay

If and when your kiddos need a break from French cuisine, a visit to this "mobile trattoria" will make for happy tummies.

Situated inside a storage container along the Les Berges promenade, or fixed outside the Musée d'Orsay, find this eatery to enjoy a small selection of appetizing delights. With a traveling food truck as well, you may also stumble upon their portable pantry at the Carreau du Temple or the Saint-Martin canal.

Adults will appreciate the creamy goodness of three fresh mozzarella options on golden focaccia sandwiches, while youngsters might want to skip straight to dessert. Enjoy a scoop of ice cream or chocolatey Focaccia Nutella for a sweet treat.

ROSA BONHEUR
SUR SEINE
RESTAURANT

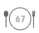

7th arrondissement
Berges de Seine Rive Gauche
port des Invalides
Quai d'Orsay

Ⓜ⑧⑬ Invalides
ⓇⒺⓇ Ⓒ Invalides

Step into the Seine without getting wet with a visit to this riverside restaurant. Situated within a stationary barge alongside the Pont Alexandre III bridge, you'll find an airy atmosphere perfect for enjoying a unique dining experience with a pleasant menu and an enticing atmosphere with favorable views.

Make sure to secure an outdoor table to witness the sunset or watch other (moving) boats drift by while you enjoy a glass of wine, a pleasing pizza for your kids, and a taste of tapas.

Perhaps you can grab a turn at the foosball table if there's a bit of a wait, or wave at the fellow visitors sailing by on a tour boat.

If a dance party with twenty- and thirty-somethings isn't appealing, be sure to dine before the late hours, when the boat starts a rockin'.

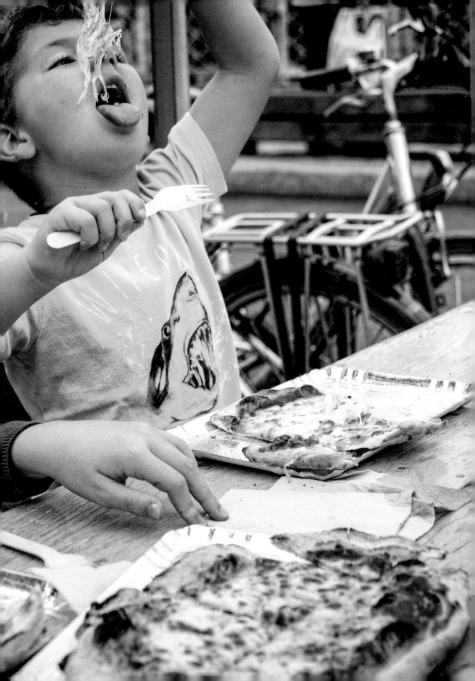

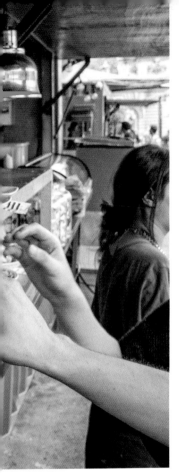

FLOW
RESTAURANT

 68

Enjoy an entirely al fresco eating experience at this outdoor restaurant on the bank of the Seine river. Whether you grab a seat at a proper table to fit the whole family, or line up in a lazy row of lounge chairs to enjoy a cold beer, you'll appreciate the airy ambiance—assuming the weather cooperates.

Large canopies will protect you from blazing summer sun while your kids dine on large, juicy cheeseburgers with fries. There's nothing formal about this eatery, so it'll be perfect for your noisy troops, as a break from their best behavior inside museums and monuments. The kitchen is housed within a shipping container, so it has its limitations, but you can depend on chilled beverages, large portions, and an easygoing energy. Prices aren't low by any means, but reasonable, and you're paying for the locale as much as anything.

Feel free to take advantage of the free Wi-Fi if you're feeling out of touch, or stay in your vacation bubble, disconnected from the outside world, and simply enjoy the view.

The music might be blaring, so come prepared for a bit of a party atmosphere at this popular and populated spot, especially as the late-night crowd starts to gather. Of course, plans are in the works for a move to a floating vessel, akin to Rosa Bonheur sur Seine (page 152), so your experience might be entirely new if Flow has hit the water by the time you visit. The restaurant website hints at a multi-purpose space that combines the eatery with a rooftop bar and concert venue.

7th arrondissement
Berges de Seine Rive Gauche
port des Invalides
Quai d'Orsay

www.flow-paris.com

Ⓜ❽⓭ Invalides
🄬ⓒ Invalides

MUSÉE D'ORSAY
ORSAY MUSEUM

7th arrondissement
1 rue de la Légion d'Honneur

www.musee-orsay.fr

Ⓜ⑫ Solférino
ⓇⒺⓇ Ⓒ Musée d'Orsay

Magnificent and almost magical, as far as museums go, the Musée d'Orsay cannot be missed on your holiday in Paris.

The adventure begins even before you step inside, with giant sculptures adorning the courtyard—don't get caught unawares in the face-off between the elephant and rhinoceros.

Making your way indoors, you'll gaze in awe at the grand, light-filled archway (128 feet high) of the former train station, with its antique beaux-arts architecture.

Whether it's impressionist paintings, vintage photographs, or antique decorative arts that interest you and yours, it's easy to find enjoyment within this breathtaking museum.

Under the skylights of the main hall, you'll see more than fifty stunning sculptures on display, including depictions of Narcissus, Joan of Arc, and Napoleon Bonaparte on horseback. Of course the large, bronze lion might be most popular among your wee ones.

Truly one of the most special and impressive pieces housed within is the Musée d'Orsay clock, by Victor Laloux, with its ornate decoration overlooking the collections of artworks inside. And yet another imposing clock, located on the fifth floor, allows you to peek out over Paris from in between its giant hands.

As you continue your journey deeper into the museum, feast on mesmerizing masterpieces from the likes of Édouard Manet, Paul Cézanne, and Vincent van Gogh—just to name a few.

A personal favorite is François Pompon's *Polar Bear* sculpture; perch on the bench nearby to take in his subtle smile.

Perhaps a ballerina in your family will appreciate the collection of Edgar Degas' dancers up on the fifth

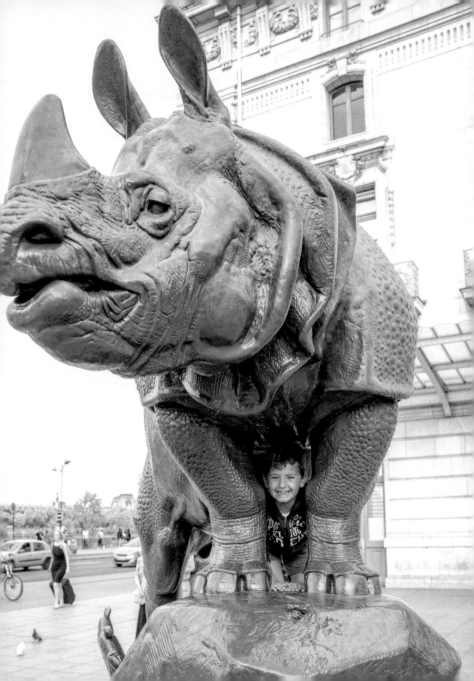

floor, alongside exquisite landscapes by Claude Monet. And if Monet is to your liking, don't miss *Le Bassin aux Nymphéas* (The Water Lilies Pond) and *Nymphéas Bleus* (Blue Water Lilies).

Be sure to find the sprawling model of Paris, which is situated under glass, so that your kids can walk atop it and examine its details from a child's eye view; the large Paris Opéra model is also a big hit.

If you purchase tickets online ahead of time, you can skip the longer line and make your way inside at Entrance C. You might also consider renting a tablet tour guide (or download the museum app) with touchscreen capabilities to help enhance your children's exploration with an interactive experience for English speakers. (If your children happen to speak French, you can also sign them up for a guided tour, giving you ninety minutes of uninterrupted parental freedom.)

When the interior of the Musée d'Orsay becomes tiresome (if ever it does), make your way to the roof to look out over the Seine and get a breath of fresh air.

Enjoy lunch or a snack in one of the museum's two cafés or its restaurant; you can find salads, sandwiches, and a selection of pastries, among other menu items.

There's a bookshop devoted entirely to children that you'll want to explore before heading on your way. If your kids enjoyed certain artists in particular, or even the museum overall, you can find related titles geared specifically toward their age group.

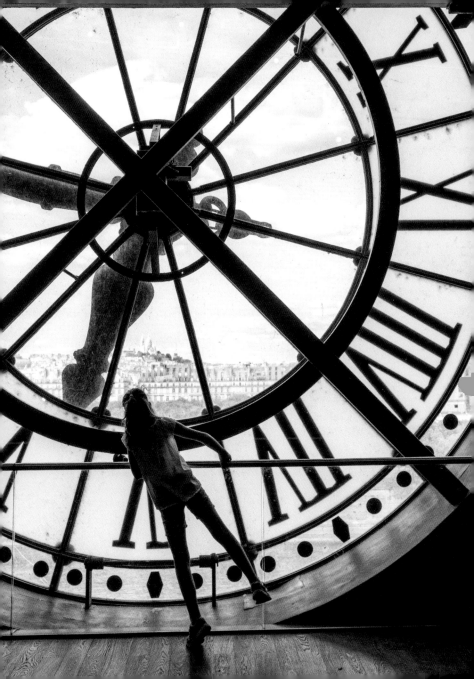

MUSÉE DE CLUNY
MUSÉE NATIONAL DU MOYEN AGE

NATIONAL MUSEUM OF THE MIDDLE AGES

70

5th arrondissement
6 place Paul Painlevé

www.musee-moyenage.fr

Ⓜ⑩ Cluny - La Sorbonne
Ⓜ④ Saint-Michel or Odéon
🆁🅑🅒 Saint-Michel - Notre-Dame

Discover the highs and lows of the Middle Ages within the Musée National du Moyen Âge, more commonly called the Musée de Cluny. Housed within a Renaissance mansion, with its collections of paintings, sculptures, textiles, and antique relics, your family will dive into an engrossing experience of the captivating era.

Perhaps the most popular piece within is a series of six tapestries, dubbed *The Lady and the Unicorn*, which depict the five senses, plus sensuality, in rich, colorful weavings. Outside, you will find the Unicorn Forest, which was inspired by the tapestries; and you can wander along through the herbs of the kitchen garden and blossoming flower meadow as well.

Your kids may find the remains of the Roman bathhouse fascinating, as they encounter the decorative elements (find the dolphin!) and learn about the complex operating systems in place—not to mention the strangeness of public baths.

Encourage your youngsters to consider the challenges of daily life in the Middle Ages. Weapons, furniture, kitchenware, and farm equipment can help to tell the story. You'll also have the chance to examine gorgeous stained-glass windows up close—a rare opportunity for an artwork usually situated high above.

And whether or not you've made it to Cathédrale Notre Dame de Paris (page 16), you can appreciate the collection of sculptures that once adorned the facade of the church, including the heads of the kings of Judah. Check the museum's calendar of events, and if your schedule lines up, a little medieval concert will entertain your entire group.

Admission is free for anyone under eighteen years old, and English descriptions make it simple for those of reading age to learn, understand, and enjoy the exhibits on display.

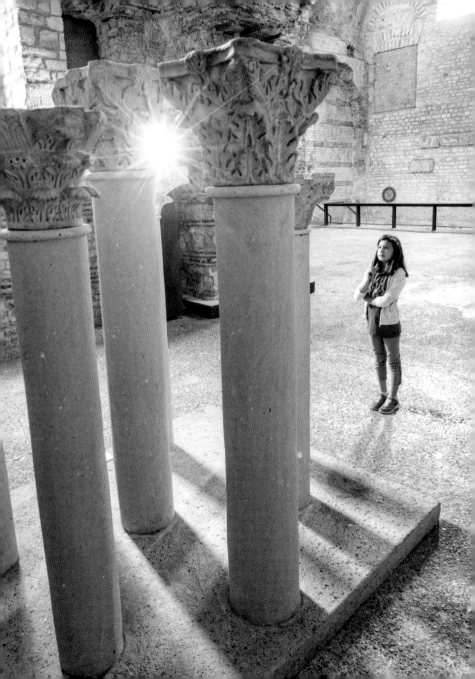

ALBUM COMICS
COMIC BOOK STORE

71

5th arrondissement
67 boulevard Saint-Germain

www.albumcomics.com

Ⓜ⑩ Cluny - La Sorbonne
Ⓜ④ Saint-Michel or Odéon
®ⓔⓡⒷⒸ Saint-Michel - Notre-Dame

Wander into this classic comic book store to reward the kids for good behavior inside the Musée du Cluny (page 160), or another of the more restrictive stops on your journey. Watch your head as you enter, as Batman himself might be rappelling from above. Whether you're on the hunt for something specific—perhaps a Tintin figurine or an issue of the *Avengers*—or merely casually perusing the merchandise, you'll find a treasure trove of goodies to explore. Almost like a mini museum for pop culture enthusiasts, the range of toys, collectibles, artworks, and reading materials on display is pretty impressive within this large shop. Old-school comics, Lego sets, and movie props are among the offerings, so pick your fangirl poison and go crazy. If your youngsters are into *Harry Potter*, you can purchase your very own wand, a Deathly Hallows necklace, or Tom Riddle's Diary.

Or perhaps the Man of Steel is your family's superhero of choice; pick up a mug or a t-shirt to show off your allegiance.

A little *Game of Thrones* swag will prove tempting, but maybe a love of manga will win out when it comes down to decision time.

If yours is the type of family who can play Monopoly without any major fights (good on you), perhaps picking up one of the many versions available—everything from *Back to the Future* to *Halo*—will prove appealing on a night back at the hotel when energy for exploring has plum run out.

Take the time to find out what franchises enthrall your flock, and search out all the best paraphernalia to "ooh" and "ahh" over, before ultimately choosing a single souvenir to bring safely back home.

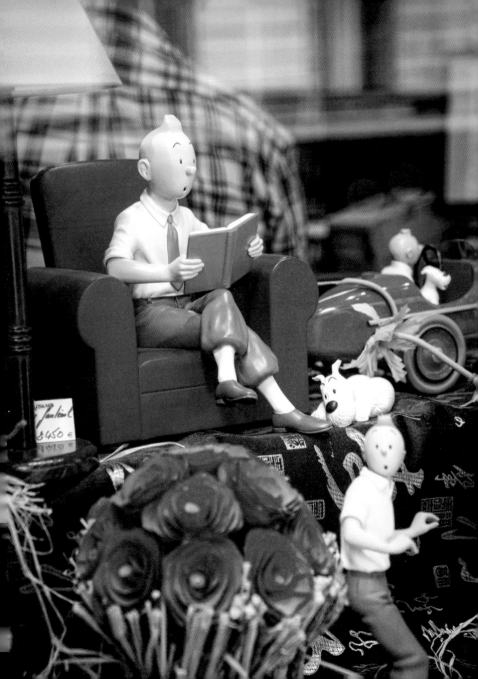

JARDIN DU LUXEMBOURG
LUXEMBOURG GARDEN

72

6th arrondissement

www.parisinfo.com

Ⓜ❹⓾ Odéon
Ⓜ⓾ Mabillon
Ⓡ🅑 Luxembourg

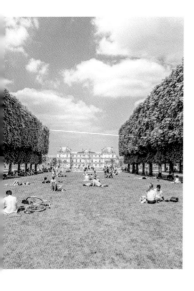

Get lost among more than sixty acres of lush, green, French and English gardens in the Jardin du Luxembourg. Nicknamed "Luco" by Parisian locals, the luxurious plot of land has been a favorite of the French for many years, perhaps since its opening in the early seventeenth century.

Based on Florence, Italy's Boboli Gardens, the area boasts white gravel paths, adorned with statues of royalty; elm, apple, and pear trees; and a large central pond where children can rent miniature sailboats to captain around the water with the wind and a trusty wooden pole.

Make your way to the Fontaine Médicis to view a stunning and romantic fountain, and stroll along the rows of blossoming flowers in every fanciful color. Don't miss the playground, which is so popular that a small entry fee is actually charged for admittance. Still, it's a worth a few euros to see your youngsters' smiling faces as they're enjoying the zip line, Eiffel Tower-inspired climbing structure, sandpit with pulley system, slippery slides, and more. You'll appreciate that the area is divided somewhat by age group, with activities for the teensiest tots separated from the rest. Adjacent to the playground is a carousel dating back to the nineteenth century. Still in working condition, your kiddos can hop on the back of a wooden horse and try to loop their complimentary batons through the operator's brass ring as they turn round and round. In the warm summer months, you may also find a marionette show or pony rides to further delight your offspring. Or perhaps an outdoor concert will spill enchanting music forth from the shady gazebo. And if you're in need of a bathroom or a café for snacks, you'll find both located on the property.

TOUR MONTPARNASSE

MONTPARNASSE TOWER

15th arrondissement
33 avenue du Maine

www.tourmontparnasse56.com

Montparnasse - Bienvenüe

Perhaps a bit of an eyesore itself in comparison with the romantic architecture of an antique Paris, this glass and steel skyscraper soars above the city's skyline. But what better way to block its image from your memory than to look out over more visually appealing views from within the tower itself?

At almost seven hundred feet tall, your kiddos will see quite the panorama once you make your way to the open-air terrace on the fifty-ninth floor. But first a trip on Europe's fastest elevator will feel like a mini amusement park ride, as your bunch ascends fifty-six floors in just thirty-eight seconds.

Exit the lift and enjoy the exhibits, including archival photography of Paris and interactive stations for your youngsters to look and learn about monuments and landmarks within the 360-degree view from Tour Montparnasse. They can even take quizzes about some of the places your vacation has taken you—challenge the family to a friendly competition to see who has soaked up the most new knowledge.

In the 360 Café, grab a few refreshments to refuel before climbing the last few floors to the tippy top of your tour.

Up on the terrace your gang may need jackets, as it gets a bit breezy. But a little wind won't stop you from working together to spot favorite destinations from your trip so far, including the Eiffel Tower, Sacré-Cœur, and the Seine river. Or perhaps the grown-ups can sip on a glass of champagne from the rooftop bar while the bambinos do the searching.

As somewhat of a lesser-known tourist spot in Paris, Tour Montparnasse should provide the opportunity to avoid any cumbersome queues or overcrowded areas that would otherwise hinder your views and enjoyment.

LE CRÊPERIE BRETONNE

BRETON CRÊPERIE

14th arrondissement
56 rue du Montparnasse

www.la-creperie-bretonne-montparnasse.fr

Ⓜ❹ Vavin
Ⓜ❻ Edgar Quinet

When in France, eat as the French do, and enjoy a meal of delicious crêpes at Le Crêperie Bretonne. It certainly isn't the only crêperie in town—you have quite a few to choose from, depending on when and where your craving for the treat takes over. But if you're in the area, perhaps after a trip to the top of Tour Montparnasse, you won't be disappointed with the selection at this particular restaurant.

Serving savory galettes and sweet crêpes for more than sixty years, this eatery has its menu down pat. Grab a family-size table in the smallish, cozy dining room, and order a cup of apple cider—a traditional beverage pairing with crêpes—while you peruse the offerings. Depending on the size of your family and the time of day, you might be sharing a communal table with other tourists or some lovely French locals. One of the appeals of crêpes, of course, is that you can have one for lunch or dinner and another for dessert. So you might choose the buckwheat Roscoff (salmon, spinach, cream, and lemon) for your meal, and follow it up with a chocolate-and-salted-caramel delight. For the kiddos, you can't go wrong with something simple like ham and cheese—that is assuming you can get them to eat something substantial before skipping straight to the sweets.

Treat your youngsters to the Nutella crêpe topped with ice cream for dessert, or perhaps they'd prefer the Crêpe Suzette, with caramelized sugar and butter. Feel free to request an English menu to make your experience more convenient.

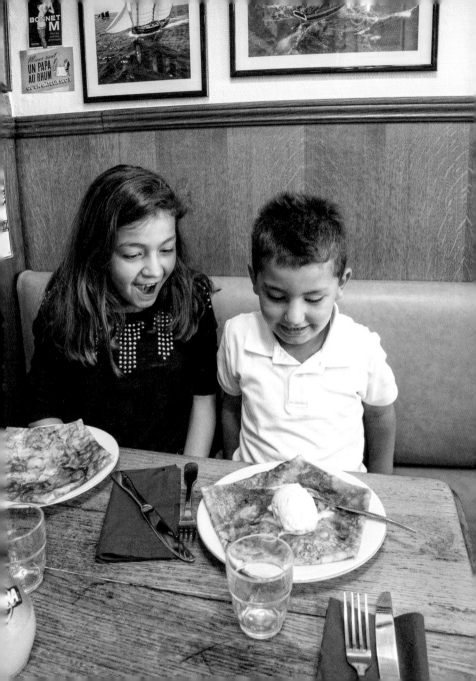

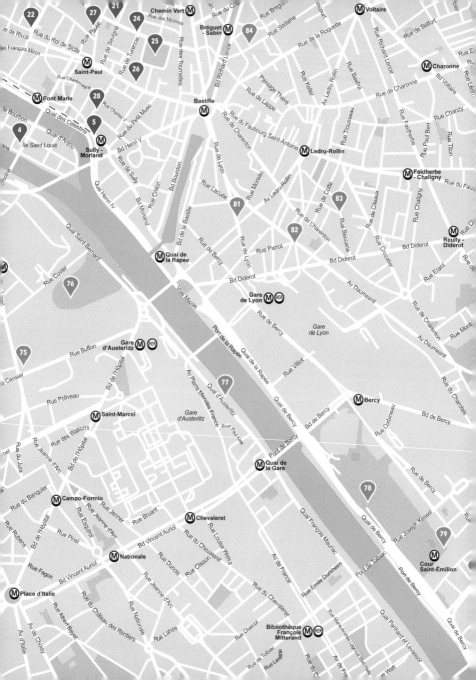

AUSTERLITZ BERCY BASTILLE

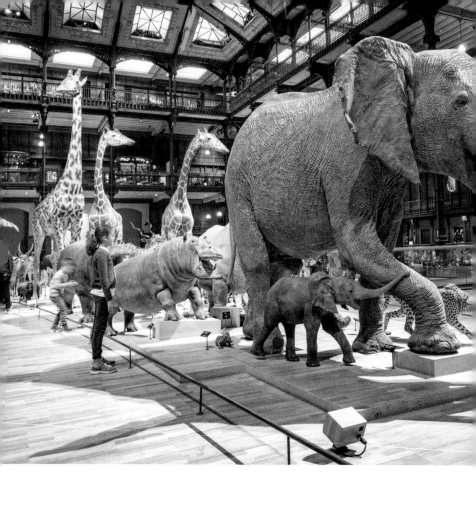

MUSÉUM NATIONAL D'HISTOIRE NATURELLE
NATIONAL MUSEUM OF NATURAL HISTORY

75

Join the parade of prominent creatures from the animal kingdom within the grand gallery of the Muséum National d'Histoire Naturelle. Although their promenade is frozen in time, your family will benefit with a close-up view of such fascinating beasts as elephants, giraffes, hippos, and zebras. Look for the imposing whale skeleton nearby!

Under the enormous glass roof of this light-filled location, your youngsters can cozy up to heaps of exhibits geared toward exciting and delighting their young senses. Keep an eye out for the audio displays to get in tune with natural environments, and don't forget there's more upstairs to uncover.

Whether it's encountering the giant skeletons of impressive birds and dangerous dinosaurs in the Galerie de Paléontologie, or examining the sparkliest crystals and meteorites in the Galerie de Minéralogie et de Géologie, your kiddos are covered for any area of interest. They'll love exploring their very own space— La Galerie des Enfants—with four areas devoted to their discovery: the city, river, rain forest, and planet. Interactivity abounds, along with colorful decor and pint-sized displays in this section of the museum devoted to six- to twelve-year-olds, with at least one parent along for the ride.

The only unfortunate aspect of this otherwise high-quality destination is its lack of English language descriptions; luckily the visuals largely speak for themselves. Outside you'll breathe a bit of fresh air in the botanical gardens, where you can stop and smell the roses—all 170 varieties on-site.

5th arrondissement
36 rue Geoffroy-Saint-Hilaire

www.mnhn.fr

Ⓜ❺ Gare d'Austerlitz
Ⓜ❼ Censier - Daubenton
Ⓜ⓾ Jussieu or Gare d'Austerlitz
ⓇⒺⓇ Ⓒ Gare d'Austerlitz

MÉNAGERIE LE ZOO DU JARDIN DES PLANTES

ZOO

Probably best to venture here after enjoying the History Museum (page 171)—when the lifeless exhibits inside that spectacular space can give way to the wild, wriggly, and unpredictable inhabitants of this Parisian zoo. Boasting the impressive honor as one of the oldest zoos in the world, the Ménagerie has been home to creatures large and small since 1794. Now featuring a family of 1200 occupants, your own flock will find a new friend or two to observe and admire within this park. Perhaps your herd will head to say hello to some of the endangered species on-site, like the cuddly-looking red panda, the sleek snow leopards, or the white-necked cranes. With a fair few tricks up their sleeves, the acrobatic orangutans will put on an intelligent show without being asked.

But every animal class is represented within the zoo, including reptiles, amphibians, birds, and creepy, crawly insects. So every goose in your gaggle should find something to interest and entertain.

Explore every Victorian-style enclosure to happen upon a hopping kangaroo or giant, prickly porcupine.

Or challenge your brood to a one-legged balancing contest next to the graceful pink flamingos.

Somewhat in need of refurbishment, and without some of the more massive mammal favorites, like lions, tigers, or (large) bears, you won't need an entire day to make your way around this smallish menagerie. Still, for the little critters in your family, an afternoon visit to this charming section of the luxurious Jardin des Plantes will prove positive.

5th arrondissement
57 rue Cuvier

www.zoodujardindesplantes.fr

Ⓜ⑤ Gare d'Austerlitz
Ⓜ⑦ Censier - Daubenton
Ⓜ⑩ Jussieu or Gare d'Austerlitz
ⓇⒸ Gare d'Austerlitz

LES DOCKS
CITÉ DE LA MODE ET DU DESIGN
CITY OF FASHION AND DESIGN

77

13th arrondissement
34 quai d'Austerlitz

www.citemodedesign.fr

Ⓜ⑤⑩ Gare d'Austerlitz
ⓇⒺⓇⒸ Gare d'Austerlitz

If you're traveling along the Seine, you'll recognize this lively locale as the building with bright green tubes snaking along the facade. It is the City of Fashion and Design—a cultural center which houses a fashion institute, restaurants, and mini museums hosting various temporary exhibitions for showcasing the arts throughout the year.

La Cité de la Mode et du Design still seems to be finding its footing as far as its overall purpose, but maybe time and experience will encourage the programming to match the interest of the exterior. You'll be somewhat dependent on the calendar of events to determine whether any options are up your alley at this riverside space.

But your main source of entertainment will be the current exhibit hosted within the Playful Art Museum. Past shows include the kid-friendly L'Art de Blue Sky Studios exhibit, which recently displayed sketches and artwork from favorite films like *Ice Age* and *Rio*. Focusing on film, video games, manga, and video games, the Art Ludique should have a little something to appeal to your youngsters.

You can also enjoy an appealing meal at Le Moonroof for some delectable Italian cuisine. Open for lunch and dinner, you'll look out over the Seine while you dine on pizza and pasta.

Of course not all of the center's offerings are particularly family friendly, like the rooftop nightclub, Wanderlust, for dancing and drinking.

If nothing else, you can enjoy a stroll (or a sprint) along the sprawling deck—or rooftop garden terrace—looking out over the water on your way to the Jardin des Plantes (page 173).

PARC DE BERCY
BERCY PARK

Stop into this public park on the right bank of the Seine to sample the bountiful beauty of its three distinct gardens: the Great Prairie, the Formal Gardens, and the Romantic Garden.

Placed on a property where a wine depot once stood, you can still seek out remnants of the vineyard and railroad. But it's the water features that will dazzle and delight, including the *Canyonaustrate* sculpture and fountain, which shares the Great Prairie garden with a large expanse of lush, green grass for playing and picnicking.

Over in the Formal Gardens, you'll find smaller sections featuring herbs and roses, but most popular with kiddos will be the Labyrinth—where they can get lost for just a bit in a maze made of hedges.

With so many distinct features to explore throughout the park, it'll be difficult to choose your favorites, but don't miss the stair-stepping Cascade fountain, or the pond surrounded by wisteria-covered columns.

Your best bet for fun might be the playground and carousel, although the rows of metal figurines along the Seine are not to be forgotten for their quirkiness and cultural significance.

You might even consider popping into the Cinémathèque Française, where you can visit their museum dedicated to film archives, including movie posters, photographs, and costumes. Or perhaps you can catch a screening of a cinematic classic like *E.T.* or *Forrest Gump*, but be sure to check on the language they're playing before purchasing your tickets.

On the other end of the park you'll find Bercy Arena—the largest indoor concert venue in Paris.

12th arrondissement
128 quai de Bercy

equipement.paris.fr

Ⓜ⑭ Cour Saint-Émilion

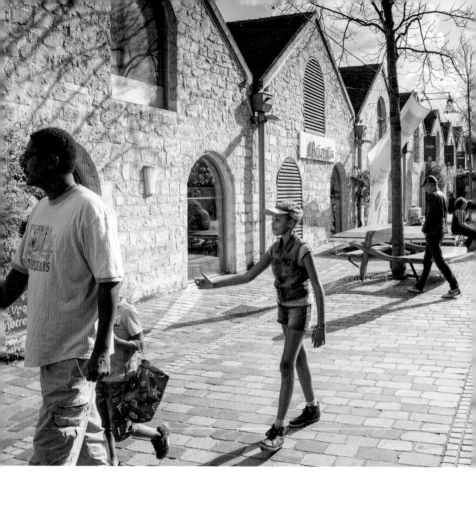

BERCY VILLAGE
SHOPPING CENTER

79

With all the charm and quaintness you could ever seek in a promenade, Bercy Village delivers a sweet little area to browse, buy, brunch, and more. Formerly a wine market, you can see remnants of the railroad running through the area, alongside the renovated wine cellars that now serve all manner of merchants.

Like the town square in a children's fairytale, the paved, pedestrian courtyard is home to small shops and restaurants for dawdling during a chunk of your day. Find your fair share of clothing boutiques, along with beauty products, shoes, watches, and more. But with your youngsters in tow, your choice of where to stop in might be a bit swayed.

Animalis may be difficult to avoid, seeing as how it's home to cats, dogs, birds, and other pets just waiting to be adopted. Even if you can't pack a new puppy in your suitcase, it could be worth the time to visit the little critters impatiently waiting to escape the store.

ID Kids has clothes and accessories just for your offspring, from zero to twelve years old, in case any fashionistas in the flock are searching for some new duds to show off their Parisian swagger.

Head to the UGC Cinema to take in a family-friendly flick, but be sure to choose a VO screening of any English-language film in order to see it with French subtitles—VF indicates that the movie will be dubbed over in French.

When shopping and strolling has reached its end, you can cozy up at a table along the avenue for some outdoor dining at Hippopotamus or The Frog.

12th arrondissement
28 rue François Truffaut

www.bercyvillage.com

Ⓜ⑭ Cour Saint-Émilion

LE MUSÉE DES ARTS FORAINS
THE MUSEUM OF FAIRGROUND ARTS

12th arrondissement
53 avenue des Terroirs de France

www.arts-forains.com

 Cour Saint-Émilion

Elegant and enchanting meets a little bit of eerie ambiance in this private museum dedicated to antiques of carnivals and fairgrounds.

You'll need a reservation in order to visit (unless your vacation falls in September or December, during their open house days), so gather your facts before booking tickets. Fortunately, your admission includes a guided tour lasting ninety minutes so you'll be protected from lifelike mannequins—and more likely to comprehend and enjoy the artifacts on display. Some have mentioned scheduling English tours, but the establishment assures that French is the only option, so do ask for their English handout. That way your group will still enjoy all of the visual treats, amusements, and even the humor of your guide as you journey throughout.

During your exploration of Le Musée des Arts Forains, you'll discover five different worlds, including the Cabinet of Curiosity and the Venetian Rooms. As you encounter each exhibit, your youngsters will have the opportunity to ride on a gondola carousel, watch an Italian opera show, or play an antique fair game. Enjoy your trip back in time to a world without Wi-Fi, as you carefully consider all of the quirky and intricate artwork that adorned carnival attractions in days of yore.

You'll even get a bit of fresh air with a trip out to the garden, where crystal chandeliers make you feel fancy as you frolic among the foliage.

Charmingly distinct from any other activity in Paris, this unique and unusual experience will be one to remember for every member of your troupe.

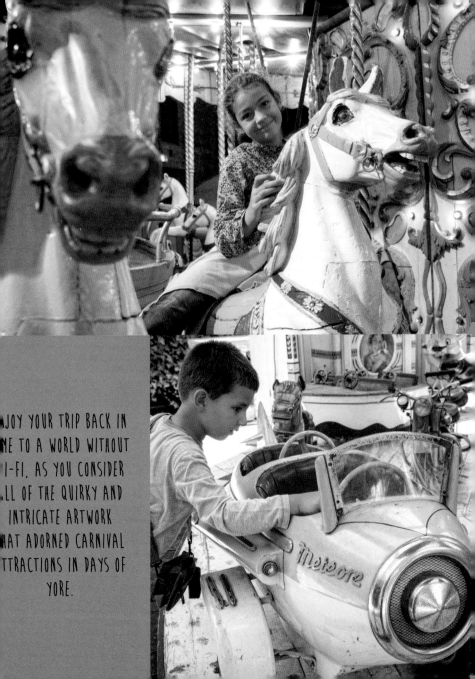

JOY YOUR TRIP BACK IN
ME TO A WORLD WITHOUT
I-FI, AS YOU CONSIDER
LL OF THE QUIRKY AND
INTRICATE ARTWORK
HAT ADORNED CARNIVAL
TTRACTIONS IN DAYS OF
YORE.

LA COULÉE VERTE RENÉ-DUMONT
LA PROMENADE PLANTÉE
ELEVATED PARK

81

12th arrondissement
44 rue de Lyon (start)
17 rue Hector-Malot (lift)
105 avenue Daumesnil, passage
Hennel (lift)

www.parisinfo.com

Ⓜ❶❺❽ Bastille
Ⓜ⓯ Gare de Lyon
ⓇⒶⒹ Gare de Lyon

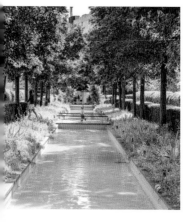

Inspiring the similar attraction that is New York City's High Line, this elevated park became the first of its kind in the world upon completion in 1989. Making use of an abandoned nineteenth-century railway viaduct, La Coulée Verte stretches almost three miles throughout Paris from the Opéra de la Bastille to the Bois de Vincennes.

It sits about three stories high, with various staircase (and elevator) entrances along the way. High above the normal bustle of the city, you can appreciate the air up here as you admire the architecture of the adjacent buildings from your pleasant perch among all sorts of greenery. Take in the sweet fragrances of your surroundings, as you pass by cherry and maple trees, rosebushes, and calming lavender. A mix of wildflowers and vegetation with careful landscaping makes your walk varied and vivacious.

Less populated than other tourist attractions around Paris, you'll enjoy plenty of elbow room (other than a fair amount of runners) as your flock saunters along away from the pedestrian and auto traffic below. When else can you allow your kiddos to safely play on the train tracks?

Not all of the route is elevated, as the trail passes through the Jardin de Reuilly midway—with a slightly buoyant footbridge over the lawn—and continues on at street level.

If you're tuckered out as you reach the garden, you can end your journey early with a pit stop at the playground, where jungle gyms, public restrooms, and Wi-Fi will feel like welcome luxuries. That is, of course, if you don't mind missing the mysterious tunnels that appear on the rest of the walkway.

When you're ready to descend back to Earth, consider combining this outing with a visit to Le Viaduc des Arts (page 184) for an enjoyable browse.

LE VIADUC DES ARTS
ARTISTS WALKWAY

82

12th arrondissement
from 1 to 129 avenue Daumesnil

www.leviaducdesarts.com

Ⓜ❶⓮ Gare de Lyon
Ⓜ❶❺❽ Bastille
Ⓜ❶❽ Reuilly - Diderot
🆁🅐🅓 Gare de Lyon

Down below the enchanting, elevated walkway of La Coulée Verte (page 182), you'll find a collection of boutiques where local artists and artisans display their wares.

Under the red-brick arches of the transformed railway viaduct, these studios and shops offer a wide range of impressive and intriguing goods to admire and ultimately take home as gifts and souvenirs.

Just a few of the residents include furniture builders, violin- and flute-makers, and interior designers. Check out the incredible mosaics of Lilikpó Workshop, the gorgeous wedding dresses of Aurélie Cherell, or the elegant umbrellas of Parasolerie Heurtault. At Le Bonheur des Dames, you can examine exquisite embroidery depicting scenes from childhood and everyday life.

Whether you're in the market for leather goods, jewelry, or a piece of artwork to commemorate your unforgettable vacation, this is the place to peruse and possibly purchase.

Keep an eye out for demonstrations, and take the chance to marvel at the processes that create such mysterious masterpieces from all manner of workshops along the way.

Even if you're just window shopping, as you loop back from your one-way trip on La Coulée Verte, the displays of the area's residents will dazzle and delight. When you're finished browsing, your gang can grab an outdoor table for a lazy lunch. The Watering Can (L'Arrosoir) has salads, sandwiches, and ice cream to alleviate your appetites. Otherwise the kids menu at Le Viaduc Café may prove tempting, with its cheeseburger and french fries, chicken fingers, or steak frites options.

Consider checking the Viaduc des Arts website before visiting if you have your heart set on more than window shopping at certain retailers. Some studios have odd hours or may be closed on weekend mornings when you're strolling before brunch.

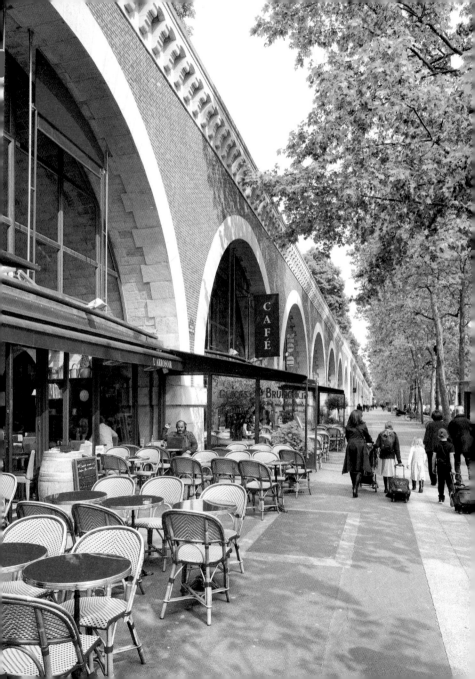

MARCHÉ D'ALIGRE
ALIGRE MARKET

83

12th arrondissement
place d'Aligre

equipement.paris.fr

Ⓜ️⑧ Ledru-Rollin

Discover an array of traders and craftsmen selling their vibrant, multicultural goods at this energetic market filled with flowers, fruit, fashions, and other fantastic finds. Partially covered from any troublesome weather, with certain stalls out in the sunshine, your family can weave your way through this tapestry of tasty treats and savvy salespeople touting their treasures.

Whether or not you're in need of produce, it might liven up your day to be among the flavorful fragrances, and perhaps you can convince your brood to ingest undoubtedly their first apple, orange, or banana of your dessert-filled vacation.

Perhaps a little French fromage will please your palates, in which case you can locate a Gouda selection. Look for overflowing bunches of herbs, bright and beautiful bouquets of flowers, and juicy cuts of meat. You won't have to seek out the seafood, since the smell will tell you right where it's located. Feel free to shop around, since some vendors will have similar items, and you want to get the best bang for your buck.

Morning visits are recommended to find the freshest foods and deals, in which case you can also pick up an excellent cup of coffee or espresso. Your kids may have a hard time keeping their paws off the merchandise, so it's best to have breakfast beforehand, unless you're prepared to buy on-site.

If you prefer a bit of entertainment with your browsing, stop by Aux 4 Saisons d'Aligre, where the charming, mustachioed owner will be working the crowd around his vegetable stand.

And if you're looking for something vintage, quirky, or just plain weird, you can head to the adjacent flea market: Marché aux Puces d'Aligre. Here you can scrounge around for a colorful picture book, a kitschy piece of artwork, or another man's trash to turn into your personal treasure.

LE CAFÉ DES CHATS
THE CAT CAFÉ

11th arrondissement
9 rue Sedaine

www.lecafedeschats.fr

Ⓜ ① ⑤ ⑧ Bastille

Curl up like a kitten among actual kittens at Le Café des Chats—The Cat Café. If you're allergic to felines—or pretend to be—steer clear, but otherwise take the chance to relax with a cup of tea and a new furry friend.

The four-legged residents of this restaurant all came from shelters and are now getting a second chance at a happy, lazy life. Softly sleeping or lolling around among your legs, the café's cats will just do their thing while you dine on dessert or sip on a cappuccino. And as it is their roost to reign over, there are written rules not to break, including waking the cats, forcing them into your lap, or feeding them any treats from your plate of goodies.

Be sure you're plenty comfortable with the company of kitties before you step foot inside, as they are abundant and not afraid to ask for attention, even jumping up on the tables where you sit.

Of course, the smell inside is indicative of a home to multiple cats. Still, the fragrance is not entirely overwhelming, and—especially if you're a cat owner yourself—you'll adjust easily in order to enjoy a snack or meal.

Your kiddos will certainly appreciate the chance to hang with the playful creatures, and they can devour a croque-monsieur (grilled ham and cheese) or burger and fries in between petting the purring pussycats. Pair that with a cup of hot cocoa and a chocolate chip cookie, and you'll have a litter of happy campers on your hands.

THE FOUR-LEGGED
RESIDENTS OF THIS
RESTAURANT ALL CAME
ROM SHELTERS AND ARE
OW GETTING A SECOND
ANCE AT A HAPPY, LAZY
LIFE.

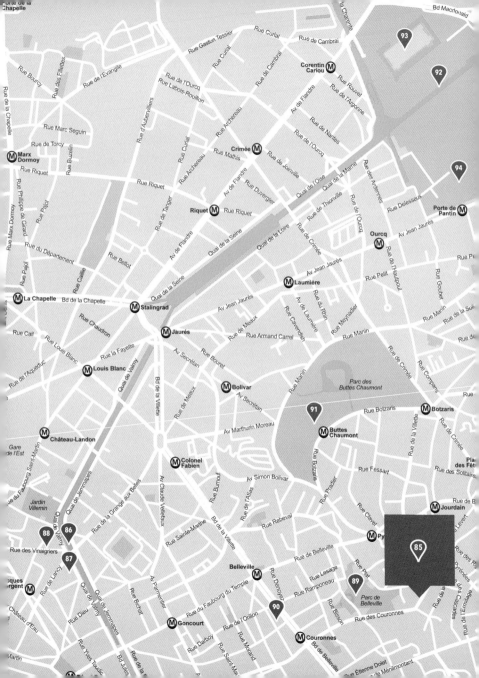

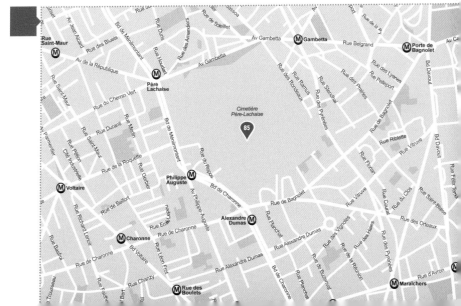

CIMETIÈRE DU PÈRE-LACHAISE

PÈRE-LACHAISE CEMETERY

85

20th arrondissement

www.pere-lachaise.com

Ⓜ❷❸ Père Lachaise

Perhaps not your typical tourist attraction, this particular Parisian cemetery is a who's who of notable personalities of French and international acclaim. It goes without saying that visiting during the day is in your best interest to ward off any semblance of eeriness as you explore the lovely landscaping of the park and the impressive monuments to famed figures. For the literary buffs in the family, you'll want to pay respect to writers like Oscar Wilde, Marcel Proust, and Sarah Bernhardt. Or if music is anyone's great

passion, he or she will appreciate the chance to honor the mysterious Jim Morrison, or the tragic Édith Piaf. Composer Frédéric Chopin is also laid to rest here, as well as seventeenth-century actor Molière and painter Théodore Géricault.

The sculpted memorials that dot the cemetery can be quite fascinating, even if the honoree is unfamiliar—such as Victor Noir's life-size statue, or François-Vincent Raspail's prison-esque tomb.

If your kids have no such morbid interest in examining the gravestones of famed folks like novelist Honoré de Balzac, or choosing the creepiest tombstones throughout the area, then your visit may be rather brief.

But if spookiness happens to be a selling point for your brave little rugrats, a sunset stroll along the pathways will set the stage for scary stories, especially should you find yourselves somewhat lost within the maze-like premises. (Purchase a map at the main entrance, or search out specific graves on the cemetery's website.)

Of course, ultimately the charming scenery and almost romantic quality to the stone facades and one-of-a-kind monuments will make for a pleasant promenade through Cimetière du Père-Lachaise, whether you're in it for a haunt or a jaunt.

LA PATACHE ROTISSERIE

RESTAURANT

10th arrondissement
60 rue de Lancry

Ⓜ③⑤⑧⑧⑪ Republique
Ⓜ⑤ Jacques Bonsergent

Near the Canal Saint-Martin (page 194) you'll find this cozy restaurant ready to feed your family one of its finest French meals. The menu is packed with indulgent comfort foods to fill you up entirely at dinner—no midnight snacks needed.

You might want to start off with a glass of wine to pair with your charcuterie and cheese boards, a couple of particularly popular offerings; or perhaps you'll try the wild boar and chestnut casserole.

Simple concepts with great flavor, like steak, chicken, and lamb, shouldn't be too intimidating to picky eaters in the bunch, ensuring that every diner has a happy experience. Otherwise, there's always salad, potatoes, and the bread basket to appease any finicky appetite.

Helpful servers will assist you in navigating the French menu, in case you have no intention of ordering the snails—served cold.

CANAL SAINT-MARTIN

SAINT-MARTIN CANAL

87

10th arrondissement

www.pariscanal.com

Ⓜ❹❺❼ Gare de l'Est
Ⓜ❷ Colonel Fabien
Ⓜ❸❺❽❾⓫ République

Perhaps not as famous as the abundant waterways of Venice, Italy, you'll still find enchantment among the shady trees and arched footbridges along the Canal Saint-Martin.

You may choose to see the stretch by boat on a river cruise with Canauxrama, taking a relaxing two-and-a-half-hour tour complete with English commentary regarding historic Paris. Another offering, Paris Canal, provides a similar experience, so it might ultimately be the pricing or schedule that impacts your final decision.

Of course, you can also enjoy the area without leaving firm ground with a saunter along the scenic walkways surrounding the canal. You'll most likely spot a slew of love locks on one of the bridges you cross, and you can decide whether to discretely add your own to the collection.

Plenty of popular cafés, shops, and bars will appear along your journey as well, in case you decide to make a pit stop or two while you wander by the water. Consider grabbing a coffee at Le Petit Château d'Eau to start your day off on the right foot. Pop into the Artazart bookstore to peruse beautiful art and design books. And after strolling starts to awaken your appetite, you can stop for a picnic lunch from Pink Flamingo pizzeria (page 46).

Maybe you'd prefer to explore the four-and-a-half kilometers of canal with the whole gang on two wheels—in which case you can rent a couple of tandem bikes at Cyclo Pouce in order to tootle around as a pack of pedalers.

If there's no time to cross every bridge and dot every *i*, you can opt instead for brunch by the bank—pick a table at Chez Prune or Hôtel du Nord for waterside dining and drinking. These, among other nearby eateries, offer a taste of local flavor with residents stopping in for their morning coffee or plopping down after work to wind down with a glass of wine.

CANAL ST. MARTIN, BELLEVILLE, LA VILLETTE

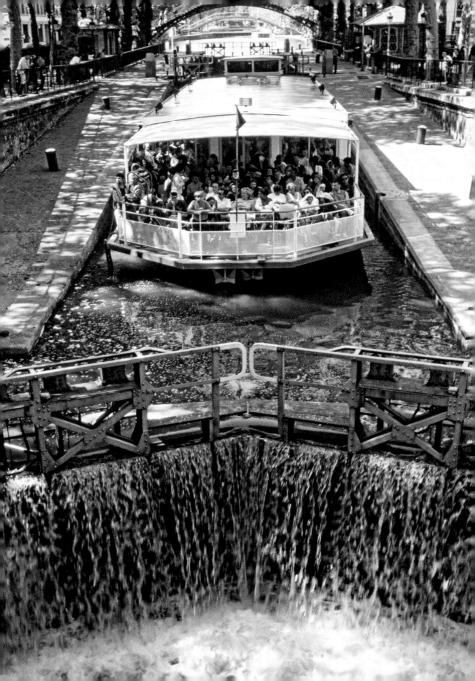

ANTOINE & LILI
CLOTHING STORE

88

10th arrondissement
95 quai de Valmy

antoineetlili.com

Ⓜ❹❺❼ Gare de l'Est
Ⓜ❺ Jacques Bonsergent

Embrace the pink with a visit inside this vibrant shop just popping with color—albeit mainly the prominent rosy hue, other than large sections of pale yellow and green on the exterior.

Of course in addition to eye-catching interior design, Antoine & Lili offers an impressive collection of grandiose gifts, eclectic home-wares, and darling outfits for your adorable offspring.

Nothing says bland or boring inside the vivacious store, so come prepared for bold prints, loud patterns, and generally a sheer sense of quirky fun. For the rare child who may actually enjoy shopping, the candy-colored garb will certainly appeal with cutesy coats and floral pajamas.

Otherwise, while you peruse the charming kids clothing, your youngsters can check out the assortment of toys, including a perfectly painted pint-size piano, a tree of fuzzy puppets, and a variety of animal masks.

A few things you never knew you needed will catch the eye of you and yours—perhaps the light-up bunny lamp or golden piglet bank, among others.

And fashions are not restricted to your wee ones; a great selection of women's clothing will make for happy moms with funky dresses, Mary Jane shoes in a handful of colors, and a pair of pink flamingo earrings. Original designs will make for one-of-a-kind style when you bring new pieces back home. And if your craving for a French béret hasn't subsided—despite the unlikely event that you've spotted any locals sporting the stereotypical hat—you can pick up just such a chapeau in red, white, or classic black.

NOTHING SAYS BLAND
R BORING INSIDE THIS
ACIOUS STORE, SO COME
PARED FOR BOLD PRINTS,
LOUD PATTERNS, AND
NERALLY A SHEER SENSE
OF QUIRKY FUN.

PARC DE BELLEVILLE
BELLEVILLE PARK

89

20th arrondissement
47 rue des Couronnes

equipement.paris.fr

Ⓜ② Couronnes
Ⓜ②⑪ Jacques Bonsergent

Yet another park within Paris, and then again—just as you've undoubtedly found in others throughout the city—Parc de Belleville has its very own charm and charisma to help it stand apart from the rest.
Quite a bit younger than some of its French counterparts, at just about twenty years old, this property has the undeniable benefit of an incredible view of Paris, especially enticing at sunrise or sunset. From your vantage point overlooking the metro area, your family will enjoy checking out the stunning skyline, including the Eiffel Tower looking as tiny as the trinkets sold in every souvenir shop.
Wind your way through the smallish premises, stopping at terraces and waterfalls along your stroll. You'll encounter stairways completely shaded with thick tree branches overhead and shuffle along paved paths lined with fallen leaves.
Don't miss the belvedere at the top of the park, where commissioned artwork decorates the columns in a vibrant palette.
Your main mission will be making your way to the playground, also known as the Village en Bois (Wooden Village). Recently restored within the last decade, you'll find an eclectic climbing structure intended to exercise and challenge your energetic youngsters. With its quirky and unique design, your kiddos might feel like they've boarded a pirate ship or ascended a tree house. Either way, it's sure to impress long enough for the grown-ups to get a quick rest on the nearby benches before the tiny adventurers slide their way back down to Earth.
If luck and nice weather are on your side, you may even find salsa dancers or other performers entertaining in the park; or a pop-up market may provide the chance to peruse a trove of souvenirs.

CANAL ST. MARTIN, BELLEVILLE, LA VILLETTE

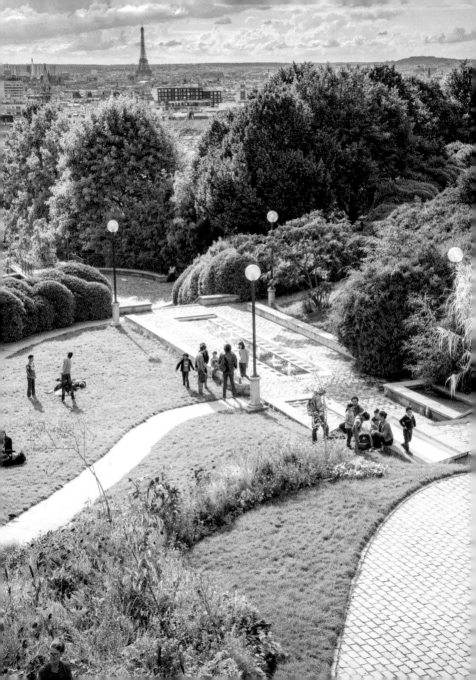

LE ZÈBRE DE BELLEVILLE

CIRCUS AUDITORIUM

90

11th arrondissement
63 boulevard de Belleville

www.lezebre.com

Ⓜ❷ Couronnes
Ⓜ❷⓫ Belleville

Enjoy an afternoon or evening of pure fun and folly with a trip to the circus or cabaret at Le Zèbre de Belleville. Unlike a zebra stuck with its stripes, this event venue changes up its performance schedule with an array of performers and concerts.

And no matter what's on the program, the vivacious and vibrant atmosphere—especially the giant backdrop bearing the theater's namesake animal—gets any audience started off on the right foot.

Still, some acts will be more kid-friendly than others, so a perusal of the website will help you decide whether to attend a show during your Parisian holiday. If the Z'Ateliers Cirque have a spot on the weekend calendar, you can bring the whole family for a little entertainment, complete with clowns, trapeze arts, stories, and music. In fact, your children may even be invited to be part of the show for a little time in the spotlight in this workshop experience. Your youngsters could discover a hidden talent for juggling or an appreciation for acrobatics that they'll remember long after your holiday ends.

Of course, language might be a bit of a barrier, but hopefully the humorous antics will translate enough for your tykes to find it all amusing and engaging. You might also check out Le Cabaret des Enfants for a two-hour combination dinner-theater performance, with a menu even your offspring will approve of: hamburgers and fries. A little magic mixed with jugglers and jokes will get the kiddos giggling in the auditorium aisles.

Whatever activity you ultimately choose, a lively energy reverberates around Le Zèbre de Belleville, and more likely than not, your family will find a galloping good time at this jovial playhouse.

PARC DES BUTTES-CHAUMONT

BUTTES-CHAUMONT PARK

91

19th arrondissement
1 rue Botzaris

equipement.paris.fr

Ⓜ �７bis Buttes Chaumont

Atop a hill not too far from the Canal Saint-Martin (page 194) sits the Parc des Buttes-Chaumont, awaiting your imminent arrival.

Formerly a garbage dump and quarry, this pleasant park has since provided a much nicer atmosphere for more than 150 years. Wandering along every avenue within this oversized property, you'll happen upon a lovely lake, complete with its very own island.

Here's where the journey really begins for your young explorers, as you step up to the swaying suspension bridge. Once you've conquered the imaginary dragon (perhaps just a skittish seagull) who lives halfway across, your gang will gain access to see the islet up close. Here you'll find a Roman-style temple, along with a mysterious grotto and whooshing waterfalls. Your youngsters will adore investigating every inch of their new kingdom, as they step into a land of make-believe with the help of the fairytale-esque surroundings. From the highest vantage point within their fortress of foliage, your offspring—and yourselves—can see out over a great expanse of the city of lights.

If the weather has your best interest at heart, your rugrats will also have the opportunity to enjoy puppet shows and pony rides elsewhere in the park.

Pick a perfectly sloping spot to stretch out for a picnic in this peaceful setting, and hear tale of adventures from the island.

When it's time for a snack and a sip of wine, head to well-known Rosa Bonheur within the park to rub elbows with a few French folk—perhaps a few too many after 6 p.m., when the crowds really start to gather. Still, earlier in the day you can't help but be charmed by the outdoor seating among the trees, where your noisy brigade can enjoy the freedoms of open air dining.

FROM THE HIGHEST
VANTAGE POINT
WITHIN THEIR FORTRESS
OF FOLIAGE, YOUR
OFFSPRING—AND
OURSELVES—CAN SEE OUT
VER A GREAT EXPANSE OF
THE CITY OF LIGHTS.

PARC DE LA VILLETTE

VILLETTE PARK

92

19th arrondissement
211 avenue Jean Jaurès

lavillette.com

Ⓜ❼ Porte de la Villette
Ⓜ❺ Porte de Pantin

Although a bit overwhelming in its gigantic size, the sheer number of activities and amusements available at the Parc de la Villette makes your visit feel like stepping into a theme park—where admission to the grounds is free.

You'll know you've arrived as you spot the array of bright red architectural follies dotting the landscape. These instantly recognizable structures serve a multitude of purposes, from first aid to fast food, as well as bringing a signature brightness to the area. With so many options for entertainment, you may want to narrow in on the best fits for your family.

The Cité des Sciences et de l'Industrie (page 207) and the Cité de la Musique (page 208) are no-brainers, so schedule those in. But when the weather is nice, take care to explore the best of the outdoors in a collection of stunning gardens along the Promenade des Jardins. The Jardin des Voltiges celebrates the circus with climbing ropes and ladders for your amateur acrobats, and in the Jardin des Vents et des Dunes your pint-size performers will practice their balancing acts.

Over in the Jardin des Miroirs (the Garden of Mirrors), get a glimpse of your weird and wonderful selves with a collection of looking glasses set among the trees.

Each garden has something new and different to experience, and you won't want to miss the chance to slay a mighty beast at the Jardin du Dragon. With its namesake slide stretching more than 250 feet long, your tiny knights will ascend to the dragon's crown before becoming the fiery breath shooting from his mouth to snake back down to Earth.

If time allows, you can wander along to check out the collection of carousels, the Grande Halle, and the Ourcq Canal for an afternoon of endless entertainment.

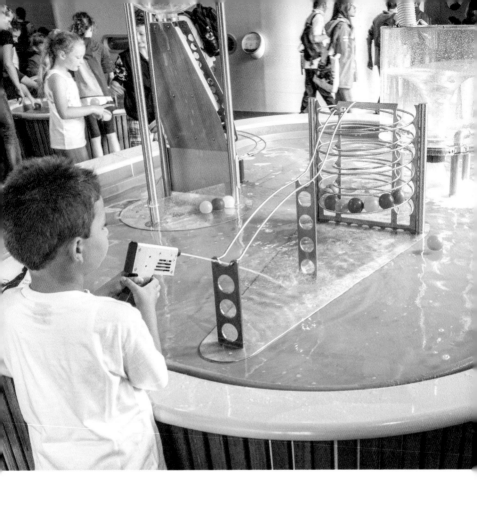

CITÉ DES SCIENCES ET DE L'INDUSTRIE
CITY OF SCIENCES AND INDUSTRY

Marked by its magnificent mirror ball—the Géode Omnimax theater—you can't miss the entrance to this masterful museum of science and industry.

With its impressive collection of permanent and temporary exhibits, this locale will prove factoids fascinating as your family explores the slew of interactive opportunities. The permanent Explora exhibition will entertain the senses as your kiddos play with light, sound, and energy. They may have the chance to simulate flying an airplane, travel through the human body, and explore the vast reaches of the stars and galaxies in the Planetarium.

The main attraction for your little Einsteins will be the Cité des Enfants—sectioned into two options based on age: two- to seven-year-olds, and five- to twelve-year-olds. With some overlap in the middle, you can decide whether to split your group or stick together. Crawling, climbing, learning, and building will flex every muscle of youthful curiosity in your tiniest tots. Over in the big kids arena, you'll find wet-and-wild water games (no swimsuit needed), sprinting tests, and some green screen fun in the music-filled TV studio.

Organization throughout the museum is a bit rough, including a complicated ticketing system for the various exhibitions, so consider booking online ahead of time, especially for your ninety-minute reservation at Cité des Enfants. Still, at the largest science museum on the continent, it's more likely you'll tucker out your troops before tiring of its offerings.

19th arrondissement
30 avenue Corentin Cariou

www.cite-sciences.fr

Ⓜ️❼ Porte de la Villette

CITÉ DE LA MUSIQUE

CITY OF MUSIC

19th arrondissement
221 avenue Jean Jaurès

philharmoniedeparis.fr

Ⓜ❺ Porte de Pantin

Across the Parc de Villette (page 204) from the Cité des Sciences et de l'Industrie (page 207), make your way to the elegant buildings of the Cité de la Musique. The complex presents beautiful architecture, exceptional concert halls of the Philharmonie de Paris, and a fascinating museum filled will all manner of musical masterpieces.

Check out the website's programming calendar to discover performances and workshops during your holiday that will suit your group. Of course you'll want to inquire about instruction language before booking any sessions where you kiddos may not understand the directions. If your youngsters are a rare breed who show interest in classical, world music, or jazz, then you might catch an evening show that pleases your whole pack.

Otherwise Le Musée de la Musique will doubtless be your destination within the melodious campus. The musical museum houses more than 7,000 artifacts for you to admire, including instruments dating back to the seventeenth century.

For your mini Mozarts, a free, age-appropriate audio guide will help you tour around the exhibits with ease. You'll all be introduced to harmonies you've never heard, guitars you've never strummed, and multicultural choirs you've never imagined. Travel through time as you explore a chronological journey of musical advancement from the Baroque Period to a much more modern era.

Keep an ear out for live musicians performing within the museum and answering questions on their expertise to enrich your overall experience.

Enjoy free admission for anyone under twenty-six years old, and take advantage of your Paris Museum Pass for reduced rates for the rest of your troop.

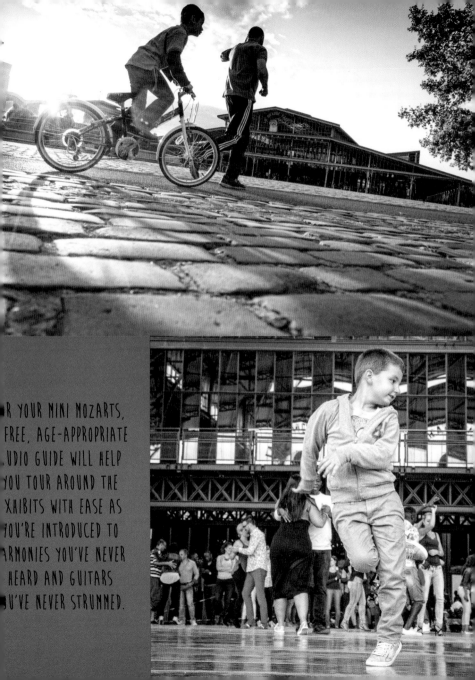

R YOUR MINI MOZARTS,
FREE, AGE-APPROPRIATE
UDIO GUIDE WILL HELP
YOU TOUR AROUND THE
XHIBITS WITH EASE AS
YOU'RE INTRODUCED TO
ARMONIES YOU'VE NEVER
HEARD AND GUITARS
U'VE NEVER STRUMMED.

OFF THE MAP

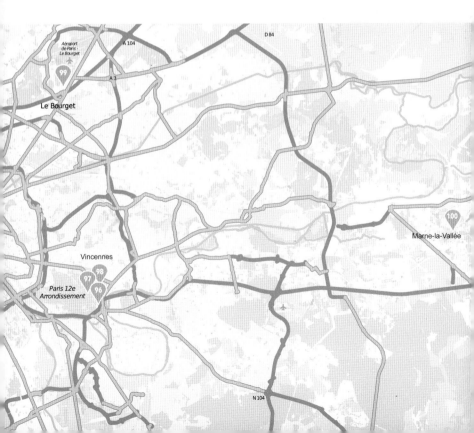

CHÂTEAU DE VERSAILLES ET LES JARDINS

VERSAILLES CASTLE AND GARDENS

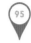

95

Versailles
place d'Armes

www.chateauversailles.fr

🚇Ⓒ Versailles Château Rive Gauche

You'd be remiss not to visit Versailles during your vacation in Paris. Just about a thirty-five-minute train ride away, it's only a hop, skip, and a jump to arrive in the lap of luxury—where you might feel underdressed as you're exposed to endless elegance.

Purchase your tickets online ahead of time (children's admission is free) or present your Paris Museum Pass at Entrance A to skip the excessive queue. You may want to choose the Passport ticket to include Le Grand Trianon palaces and Le Domaine de Marie-Antoinette in your visit—as well as the gardens if you're visiting on a weekend, or Tuesday in summer (check the web calendar), as these days include musical fountain and garden shows.

Approaching the grounds on your short walk from the train, take in the glittering gold of the main gate, the intricate adornments of the palace exteriors, and the gorgeous clock keeping time overhead.

Beginning your journey indoors, you'll visit the Château of Louis XIV, including the Queen's Apartment, the Hall of Mirrors, and the King's Bedroom. Stare in awe as you wander through the rooms of royals, admiring all manner of ornate and extravagant decor and furnishings.

A few too many halls of portraits may test your youngsters' patience, but you can make a game of naming the unfamiliar figures or counting the chandeliers throughout each chamber.

After touring the crowded Château, your flock will enjoy the freedom of strolling among the careful landscaping, exquisite sculptures, and flowing fountains within the sprawling Jardins de Versailles.

As you head out into the gardens you may want to rent a golf cart or pack of bicycles to tootle around. Otherwise you'll be in danger of walking quite a ways away from the entrance without any speedy method of

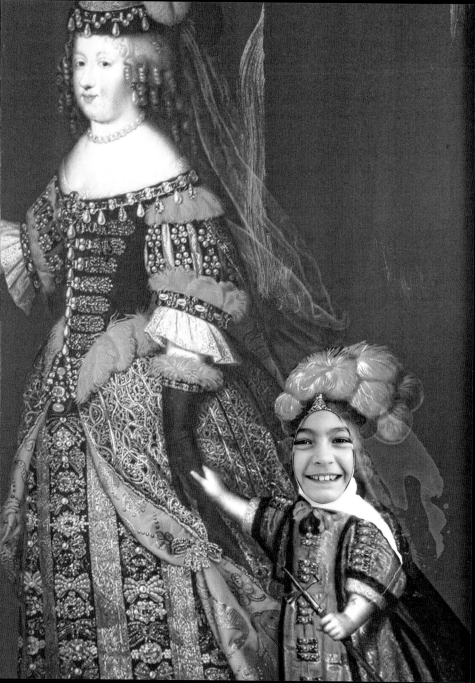

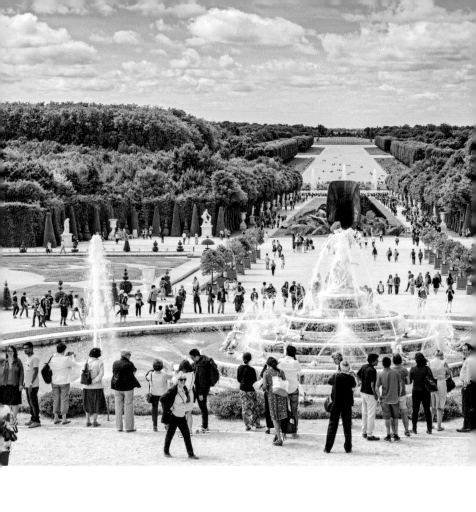

returning when fatigue (or a full bladder) sets in. Still, you'll want to take your time to admire many aspects of the premises, perhaps with a picnic along the Grand Canal, so strolling may fit your family just fine. Consider whether your kiddos will enjoy an entire day at the palace and gardens, or if half a day is all you need. If your itinerary is more flexible, you can play it by ear as your children check out the Château and its surroundings. Arriving early (even before opening) is advised, as crowds only increase throughout the day. To take full advantage of the offerings on-site, including shops, refreshments, audio and app tours, and transportation, give this particular attraction a bit more attention when reviewing the website. You'll pick up tips (no strollers allowed in the palace rooms) and tricks (take a shuttle between buildings) to arrive fully prepared for an exceedingly pleasant palace visit. Free toilets and opportunities to buy lunch are scattered throughout the grounds, so you need only to bring water and a backup snack for emergencies. Feeling extra ambitious? You can even bring a bit of stale bread or baguette to feed to the ducks at Marie Antoinette's hamlet.

If you're enjoying your day trip away from Paris, you may want to extend your stay with a ten-minute walk into the town of Versailles for an al fresco dinner on a warm summer evening.

CHÂTEAU DE VINCENNES

VINCENNES CASTLE

96

12th arrondissement
1 avenue de Paris

chateau-vincennes.fr

Ⓜ① Château de Vincennes
ⓇⒺⓇⒶ Vincennes

In the northern quarter of the Bois de Vincennes (page 218) sits an imposing and impressive palace just waiting to be explored by the likes of your family unit. Dating back to the fourteenth century, the Château de Vincennes has served a wide range of purposes in its long history, including housing King Charles V—and later holding state prisoners.

Walking up to the fortress facade, you can imagine a moat full of crocodiles just waiting to snap at your heels should you tread too close to the water.

You'll spot the keep from afar, the tallest of its kind in Europe, and check for any expert archers with an eye out for families looking to storm the castle.

If you safely gain access across the drawbridge, admission is free for anyone under eighteen. Join a guided tour for a small fee (free for children) to get the full scoop on the historical significance of each corridor within the former royal residence.

You'll have access to the king's living quarters and the castle kitchen, as well as the recently renovated Sainte-Chapelle, which features exquisite stained-glass windows dating back to the sixteenth century. Don't miss the markings left by notable prisoners, including Marquis de Sade, and the Medieval latrines situated on each floor of the fortress, which are sure to gross out your twenty-first century tots.

Check the castle and chapel's open hours online, as times may vary with changing seasons. All in all, it shouldn't take you more than an hour or so to explore this remarkable residence during your time in the Bois de Vincennes. Following your journey throughout the largest royal medieval fortress still standing in France, make your way onward to enjoy the rest of the grounds and park—namely the Parc Floral de Paris (page 281).

WALKING UP TO THE
FORTRESS FACADE, YOU
CAN IMAGINE A MOAT
ULL OF CROCODILES JUST
AITING TO SNAP AT YOUR
EELS SHOULD YOU TREAD
OO CLOSE TO THE WATER.

BOIS DE VINCENNES ET PARC FLORAL DE PARIS

VINCENNES WOODS AND FLORAL PARK OF PARIS

97

12th arrondissement
esplanade du Château de
Vincennes

www.parcfloraldeparis.com

Ⓜ① Château de Vincennes
㋡Ⓐ Vincennes

As the largest park in Paris, making up about ten percent of the city's size, the Bois de Vincennes is not one of which you will see every inch. But a little careful planning, and a survey of your family's priorities, will make for a memorable day in this lush landscape.

Choosing from the pair of lakes makes for a promising start, with opportunities for casual boating or feeding the famished ducks.

Near Lac Daumesnil, the Parc Zoologique de Paris has penguins, seas lions, pumas, and the African lion—among many others. Admission is a bit steep (starting at fourteen euros for your youngest), and there are no elephants on the premises, but recent renovations have resulted in modern design and seemingly comfortable enclosures for the critters living on-site. A straightforward layout keeps you from missing out on any monkeys or manatees; and a glass viewing area behind the giraffe habitat extends your admiration for the long-necked ladies and gents with a fairly close-up encounter.

Perhaps a bit smallish in comparison to others zoos back home, it'll be worth an afternoon if you have animal lovers in your lot.

Then again, if a zoo isn't sparking any excitement, the Bois de Vincennes has much more to offer. If animals are still of interest, you can head to La Ferme de Paris to look for perky little piglets, watch some sheep shearing, or find out if the cows need milking.

Or, on the opposite side of the grounds, somewhat near the Lac des Minimes, the Parc Floral de Paris has enormous promise for pleasing your sprouts.

Whether you're sauntering among the vibrant blossoming flowerbeds, picnicking beneath the pines, or playing hide-and-seek in the bamboo forest, this park within a park has a plethora of opportunities for enjoying the fresh air. Perhaps you'd prefer to pedal past the petals on your very own quadricycle, with the

whole team pulling its weight to keep you moving. You may find a gaggle of geese to observe, or a free summer concert to serenade your stroll. Look for the miniature golf course, complete with small-scale Parisian landmarks and monuments decorating each of the eighteen holes.

For excited explorers who like scooping up creepy-crawling insects, you may want to rent the Trésors du Parc kit, complete with compass, for a guided scavenger hunt of the flora and fauna.

From spring through fall, take a flying leap to Evasion Verte for a treetop adventure your daring posse will devour. Ropes, ladders, and zip-lines will have your gang careening through the forest like a family of Tarzans. Age and height restrictions will come into play to determine which course fits your flock.

Over at the Parc Floral de Paris playground, climbing structures and a long yellow slide will fulfill your daily quota of letting the kiddos run wild. Don't miss the bright yellow-and-blue pirate ship for gathering ye booty, and a pair of towering rope pyramids, which look a bit like Eiffel's Iron Lady. With swings, ping-pong, tunnels, and a seasonal puppet show adding to the offerings, it'll be a race against daylight to fit all the fun you can find throughout Bois de Vincennes into a single afternoon.

LES MAGNOLIAS
RESTAURANT

When hunger hits during your promenade through the pretty Parc Floral de Paris, you can count on Les Magnolias to fulfill your family's need for food. Take advantage of outdoor seating under shady pink umbrellas, where you can appreciate the kid-friendly options. Enjoy a scoop of ice cream as you take your time to relax in the idyllic setting.

MUSÉE DE L'AIR ET DE L'ESPACE
AIR AND SPACE MUSEUM

Aéroport de Paris-Le Bourget,
Le Bourget

www.museeairespace.fr

Ⓜ️⑦ La Courneuve - 8 Mai 1945
+ Bus 152 Musée de l'Air
et de l'Espace
🆁Ⓑ Le Bourget + Bus 152 Musée
de l'Air et de l'Espace

Once you've explored to the outer reaches of the Paris city limits, you might want to venture out to Le Bourget Airport. Here you can prepare your little pilots to fly you all home at the Musée de l'Air et de l'Espace.

The oldest museum of its kind, the collection includes more than 400 aircraft (150 on display), some dating back to the eighteenth century, to tell the story of airborne transportation through time.

Admission is free to enter the main museum, but an extra fee is charged to gain access to some of the most fun aspects of the grounds, including stepping inside the Concorde and Boeing 747 airplanes on-site. Within the permanent exhibitions, you'll encounter fighter planes and jets from both World War I and II, and examine the details of a real rocket up close. Don't miss the exquisite blue-and-gold hot air balloon in Débuts de l'Aviation, as well as the paper-winged creations of the early days of air travel.

Unlike some of the more bothersome tourist spots, this museum is rarely overcrowded, giving your crew plenty of elbow room to admire bombers painted with personalized cartoons, and the Galerie des Maquettes filled with miniature helicopters, military transport, and even an aircraft carrier.

Unfortunately most descriptions throughout the property are solely in French, but an English audio guide can easily assist with any cryptic corners of the collection.

On Planète Pilot, your new navigators—ages six to twelve—can spend seventy-five minutes acting as astronauts in a slew of interactive exhibits. They'll even step inside a roomy spacesuit to focus on the mission at hand, providing the perfect photo opp for sneaky parents to snap.

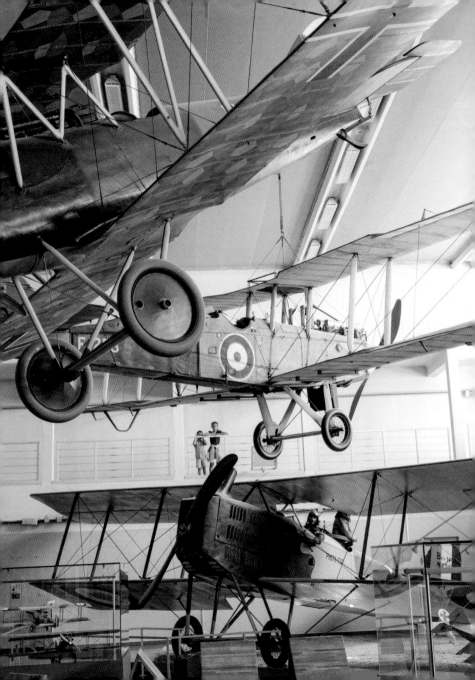

Elsewhere the flight simulators (for any reading children and older) give you the feel of actually piloting a plane from take-off to landing. And in the Planetarium, you can stare up at the stars and Milky Way galaxy (or sneak a well-deserved parental nap) from the comfort of your own reclining seat.

If you decide to tour the Boeing 747, you may find a few pigeons living inside; whereas onboard the Super Frelon helicopter you'll discover alll the necessary equipment for launching a successful Search and Rescue operation. You'll even have the chance to get a glimpse of the inner workings of these impressive aircraft with cutaway sections for kids to peek inside.

If you're visiting over the lunch hour, a meal at the L'Hélice restaurant should suffice. With a view of the Boeing 747, you may be in the mood to jet off to a new destination after refueling your own tank with a salad or burger, and crème brûlée.

Beware that luggage, ironically, is not permitted within the museum, and no coat check or lockers are available to store such items.

If your amateur aviators are looking for a souvenir, then the gift shop has an ample supply. Maybe a model airplane to build together as a team will extend your holiday long after you arrive home.

Should your visit fall toward the end of your trip, perhaps your experience will replace a familiar sense of dread for your upcoming flight—instead you can depart Paris with excitement and a newfound appreciation for air travel.

PLANÈTE PILOT, YOUR
EW NAVIGATORS—AGES
SIX TO TWELVE—CAN
SPEND SEVENTY-FIVE
MINUTES ACTING AS
TRONAUTS IN A SLEW OF
NTERACTIVE EXHIBITS.

DISNEYLAND PARIS

100

Marne-la-Vallée

disneylandparis.com

Shuttle:
Disneyland Paris Express from
Gare du Nord, Opéra, Madeleine,
and Châtelet
Magical Shuttle Airport Bus from
the Paris airports

(RER)(A) Marne-la-Vallée - Chessy

At Disneyland Paris, you can combine your European holiday with the type of vacation most kids crave: a day-long (or days-long) trip to a magical amusement park filled with fun and fancy.

Depending on the devotion of your offspring to maximize the experience, you may need more energy for this excursion than all the rest of your adventures combined. Booking it through the park from one ride to the next, standing in lengthy queues, and screaming your lungs out on Space Mountain aren't feats for the faint of heart. Rest up, arrive early, and mentally prepare to get your euro's worth during a visit to France's franchise of the famous theme park. Consider taking the Magical Shuttle directly from the Paris airport, otherwise you can rent a car or take the RER A regional train for a thirty-five minute trip from Paris to the Marne-la-Vallée - Chessy station.

You'll want to do a bit of research on the website ahead of time to plan your day. Disneyland Paris consists of two parks—Disneyland Park and Walt Disney Studios Park—so you'll need to decide whether to visit one or the other (or both) based on which attractions each has to offer.

Disneyland Park has more of your classic offerings, including Sleeping Beauty's castle, the Pirates of the Carribbean boat ride, and the Mad Hatter's Tea Cups, where you'll twirl and whirl until you can spin no more. In this park you'll find the attractions Disney is known for, like It's a Small World, Indiana Jones and the Temple of Peril, and Big Thunder Mountain. And when you need a break from roller coasters and thrill rides, you can catch a loud and colorful parade, a lesson at the Jedi Training Academy, or a meet-and-greet with the likes of Mickey Mouse himself.

In contrast, it's a bit of a brave new world over at Walt Disney Studios Park, so if you've already been on Buzz

Lightyear Laser Blast and Dumbo the Flying Elephant a dozen times on one of the US coasts, you may want to check it out. The offerings at this park are fairly unique, save for a few familiar favorites, like the Tower of Terror. Otherwise you'll discover new opportunities for enchantment, like taking a surf on the totally tubular Crush's Coaster or get swept up in Toy Story Playland on Andy's RC Racer. For superhero fanatics, some facetime with Spiderman will be appreciated. And with tiny tots in tow, a trip to the Disney Junior Live on Stage! show will get you all wriggling and giggling with this interactive dance performance. Dining is largely convenient and varied throughout the Disneyland Paris resort. So whether you're looking to grab something on the go, refuel with a cup of java, or take your time with table service at Auberge de Cendrillon, the parks have you covered. You may even be invited to share a spot of supper with Cinderella (call for a booking)—or grab a stack of shortcakes with Goofy at Café Mickey.

The seasonal park hours may help you make your choice if you decide not to visit both parks, as the Disneyland Park is often open somewhat later. Then again, you may be too tuckered long before closing for it to make a bit of difference.

If you're staying overnight at a Disney hotel, or find yourself with a touch of extra time, you can saunter about the Disney Village entertainment district to shop, and dine at restaurants like Annette's Diner or Billy Bob's Country Western Saloon.

ONE-DAY ITINERARIES

LOUVRE, OPÉRA

Begin bright and early on the expansive grounds of the Musée du Louvre, and break for lunch in a café across the street at the Palais-Royal. If you've met Mona Lisa, you can move on to the Jardin des Tuileries, where a playground, carousel, and mini trampolines await your bouncing children. Consider stopping by toy store Si Tu Veux in Galerie Vivienne for a keepsake from the day.

CONCORDE, CHAMPS-ÉLYSÉES, BOIS DE BOULOGNE

Stroll along the bustling Champs-Élysées with a stop for lunch and delicious macarons at Ladurée. Keep an eye on the prize as you walk your way toward Arc de Triomphe before heading to Jardin d'Acclimatation to delight in the amusements of a youthful paradise.

TROCADÉRO, TOUR EIFFEL, INVALIDES

Capture the iconic landmark from every angle whether you start in the Place du Trocadéro to admire the fountains or hit the playgrounds across the way. Climb the Eiffel at your assigned time, and the rest of the day is yours to spend ascending in a hot air balloon or sailing along the Seine on a sunset cruise.

ORSAY, MONTPARNASSE, QUARTIER LATIN, LUXEMBOURG

Greet the morning with sunlight streaming through the glass ceiling of the Musée d'Orsay. After bidding adieu to the polar bear sculpture, grab lunch down by the Seine at Mozza & Co. Refueled and ready for fun, you'll spend the afternoon exploring all the offerings along Les Berges. When dinner and drinks beckon, answer the call nearby at Flow for a burger or on Rosa Bonheur sur Seine for tapas with a river view.

THREE-DAY

ITINERARIES: CULTURE CROWD

Whether strolling through an impressive cathedral or tasting the delights of Parisian cuisine, soak up a sample of local life. Witness unparallelled beauty, impressive artifacts of history, and admirable artwork over three delightful days.

1 DAY LES ÎLES, LES HALLES, LE MARAIS

2 DAY MONTMARTRE

3 DAY OFF THE MAP: VERSAILLES

THREE-DAY
ITINERARIES: AMBITIOUS ADVENTURERS

Rest and conserve energy before embarking on an exciting escapade from one corner of Paris to another, exploring natural wonders, temporary beaches, and delicious bites of French fare. Find feats of local talent, collections of quirky creations, and plenty of outdoor enjoyment.

1 DAY LES ÎLES, LES HALLES, LE MARAIS

2 DAY AUSTERLITZ, BERCY, BASTILLE

3 DAY CANAL ST. MARTIN, BELLEVILLE, LA VILLETTE

THREE-DAY

ITINERARIES: WINTER WONDERLAND

Chilly weather might move your vacation mainly indoors, but stunning architecture, endless kid-friendly entertainment, and exquisite edible treats will distract from the lack of summer sun. Dazzling holiday lights, possibilities to meet Père Noël (Santa Claus), and a cozy cat café will only add to your seasonal success.

1 DAY LES ÎLES, LES HALLES, LE MARAIS

2 DAY LOUVRE, OPÉRA

3 DAY OFF THE MAP

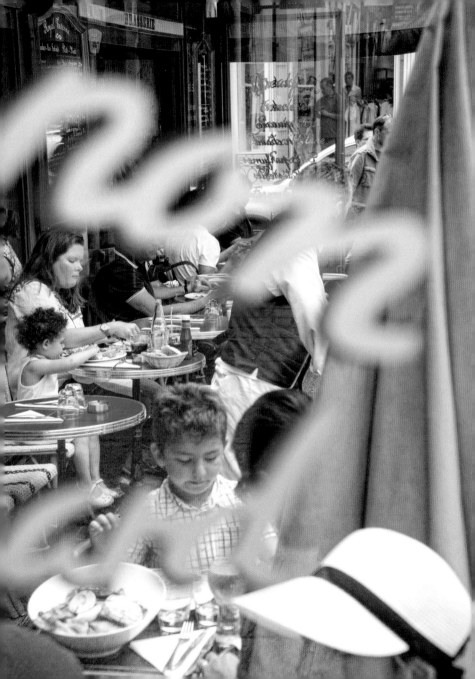

INDEX

Concept
Alberta Magris
Text
Sara DeGonia
Design
Jenny Biffis
Prepress
Fabio Mascanzoni

Photographers
Giovanni Simeone
Antonino Bartuccio p. 94, p. 105
Stefano Brozzi p. 164
Francesco Carovillano p. 19, p. 185
Franco Cogoli p. 17, p. 123
Arnaud Frich p. 133
Günter Gräfenhain p. 81
Jones Huw p. 192
Alessandro Saffo p. 80
MundySally p. 100-101
Gianluca Santoni p. 82
Henri Tabarant p. 140-141
Richard Tayolor p. 54
Stefano Torrione p. 21, p. 176-177, p. 195

All images of this book may be licensed through
www.simephoto.com

ISBN: 978-88-99180-53-9

Printed in Europe by
Factor Druk, Kharkiv

Distributed in Europe by
SIME BOOKS
www.sime-books.com
T. +39 0438 402581
customerservice@simebooks.com

Distributed in Australia,
Canada and United States
by SUNSET & VENICE
www.sunsetandvenice.com
T. 323 223 2666
sales@sunsetandvenice.com